PORTRAIT OF
WILTSHIRE

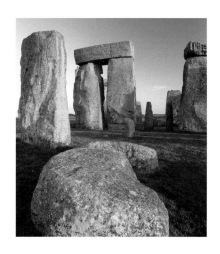

STEVE DAY

HALSGROVE

First published as *Wiltshire Moods* in 2004
This edition printed 2008

Copyright photographs © 2004 Steve Day
Copyright words © 2004 Dr Sue Walker

British Library Cataloguing-in-Publication Data
A CIP record for this title is available from the British Library

ISBN 978 1 84114 822 9

HALSGROVE
Halsgrove House
Ryelands Industrial Estate,
Bagley Road, Wellington,
Somerset TA21 9PZ
Tel: 01823 653777
Fax: 01823 216796
email: sales@halsgrove.com
website: www.halsgrove.com

Printed and bound by Grafiche Flaminia, Italy

DEDICATION

This book is dedicated to the memory of its photographer, Steve Day. He was a truly talented landscape, travel and nature photographer, who always strived for perfection. His photographic signature was undoubtedly 'light' and fabulous skies. Steve explored and adored Wiltshire and, as we shared almost every nook and cranny of this stunning county, he really opened my eyes to so many of its delights. For me, it has been a labour of love to bring to fruition a project he had so wanted to undertake himself.

Dr Sue Walker (aka Mrs Sue Day)

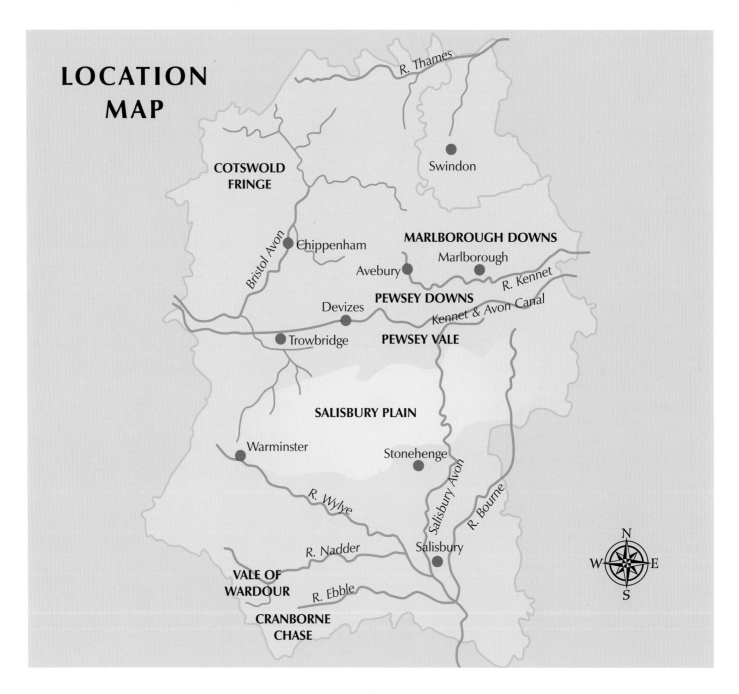

LOCATION MAP

R. Thames

Swindon

COTSWOLD FRINGE

MARLBOROUGH DOWNS

Bristol Avon

Chippenham

Avebury

Marlborough

R. Kennet

PEWSEY DOWNS

Devizes

Kennet & Avon Canal

Trowbridge

PEWSEY VALE

SALISBURY PLAIN

Warminster

Stonehenge

Salisbury Avon

R. Bourne

R. Wylye

R. Nadder

Salisbury

VALE OF WARDOUR

R. Ebble

CRANBORNE CHASE

N
W E
S

INTRODUCTION

A LITTLE KNOWN JEWEL

Wiltshire is an extraordinary county in many ways. Two thirds of it lie on chalk, which gives it gently undulating downland with small villages strung out along the many chalk-stream valleys that cut through it. The main areas are Cranborne Chase, the Marlborough Downs and Salisbury Plain, separated by the wide vales of Wardour and Pewsey, rich in farmland. Sheep have been grazing the springy downland turf for thousands of years. One third of the county, mainly in the north west, constitutes flatter pasture lands on clay with a ridge of limestone. Here there are still amazing, flower-rich hay meadows, alive with the buzz of insects. Farming remains much in evidence throughout the county.

Wiltshire is steeped in human history because its folk have been slow to sweep away their past. Quite why Wiltshire is infinitely the richest area of all England, and one of the richest in Europe, in prehistoric remains has never been fully explained. From the World Heritage Sites of Avebury and Stonehenge to the vast numbers of hillforts, burial mounds and ancient tracks, one is immersed in an evocative past. Time almost seems to have stood still since, even now, there are some 4000 miles of trackways and footpaths but few main roads, a low population and an essentially rural economy.

Salisbury Plain forms a high, seemingly empty chalk plateau in the centre of the county, and is of huge archaeological and ecological importance, because a twist of fate put most of it in military hands from the turn of the twentieth century. Making up over 10% of the area of Wiltshire, it has few roads, and much has not been subjected to agricultural modernisation. Limited public access has allowed wildlife to thrive, and the Salisbury Plain Training Area forms the largest stretch of unimproved chalk downland in northern Europe.

There are still some large and beautiful tracts of ancient woodland and, although Wiltshire is land-locked, there are lakes to relax by and glittering or misty rivers and crystal-clear chalk streams to amble beside. Five tributaries join the Avon in the cathedral city of Salisbury, giving it a stunning setting amongst water meadows to west and east, and the idyllic chalk valleys radiate out from the city like fingers.

Almost all of the photographs in this book were taken at dawn or dusk, when the lighting is magical, and the ancient landscape is devoid of people and so still it is yours alone. The use of coloured filters has been avoided - those of you who have experienced exquisite sunrises and sunsets will appreciate that nature needs no help to produce warm yellows and oranges or fiery pinks and reds.

Wiltshire has big skies, huge vistas and a tremendous sense of space. I hope that this also comes across in the images and that you, too, can be striding up on florific downs among skylarks and bleating sheep, walking upon ancient hillforts and tracks, and marvelling at the vast wilderness that is Salisbury Plain.

Sue Walker, 2004

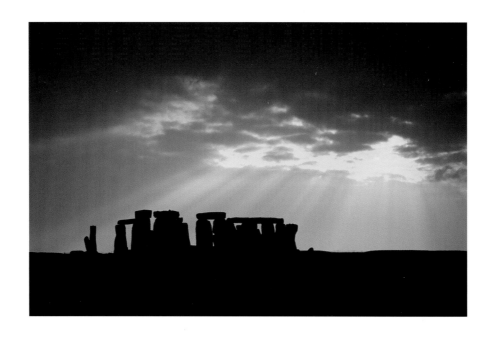

ACKNOWLEDGEMENTS

Thanks to Mike Read for encouragement and the inspiration to 'just get on and do it' when I wasn't sure I could. Sincere thanks to my Mum and Dad, my sister Jacky and Sue Holloway at work for keeping me more or less sane since Steve died. Also thanks to Jon, Sally, Judy, Mike, Barry, Barbara, Dick, Becky and Sam, for slurping gallons of wine and helping me with the final selection of photographs over many evenings, not to mention endlessly entertaining and checking up on me since Steve's death. I'm not sure I'd still even be here without you all. Bless you.

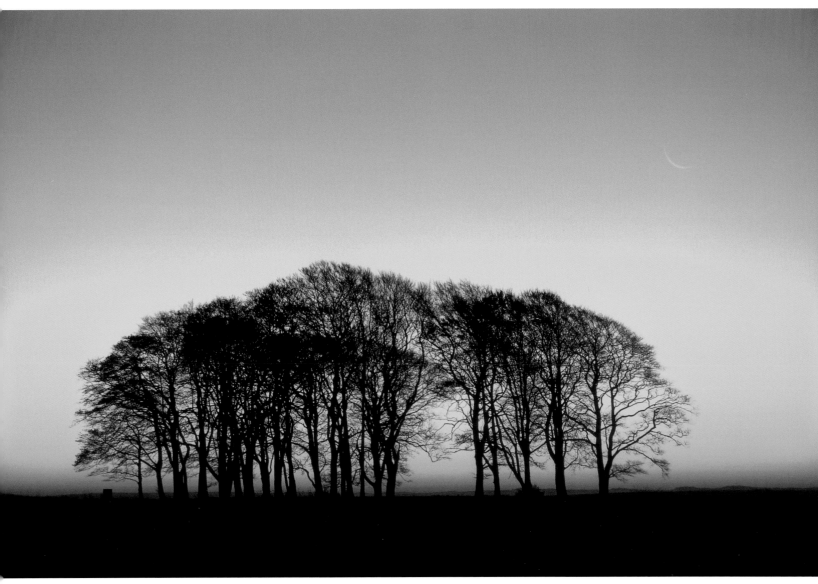

Beech clump and new moon
Clumps of beech trees often mark ancient trackways over the downs, or stand on burial mounds, and are a really characteristic feature of Wiltshire.

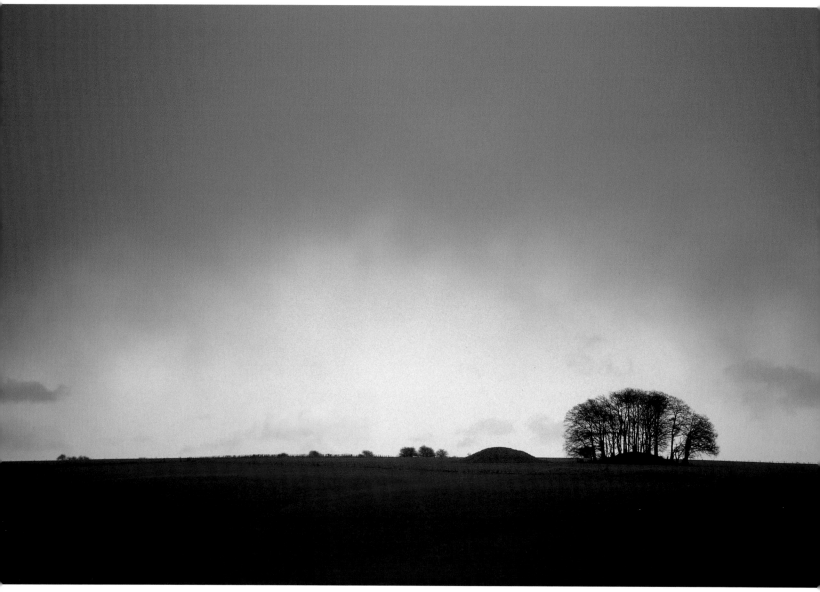

Beech clump and barrows

To walk across the rich prehistoric landscape of Fyfield Down, near Avebury,
during a storm, is to step back several thousand years.

Grey wethers

The sarsen stones littering Fyfield and Overton Downs are called grey wethers because, from a distance, they resemble grazing sheep. Many enormously heavy ones were taken to build Avebury and Stonehenge.

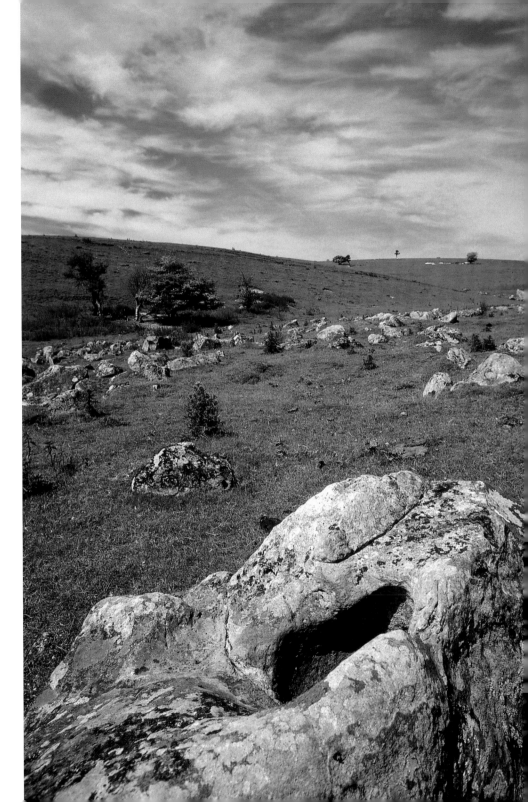

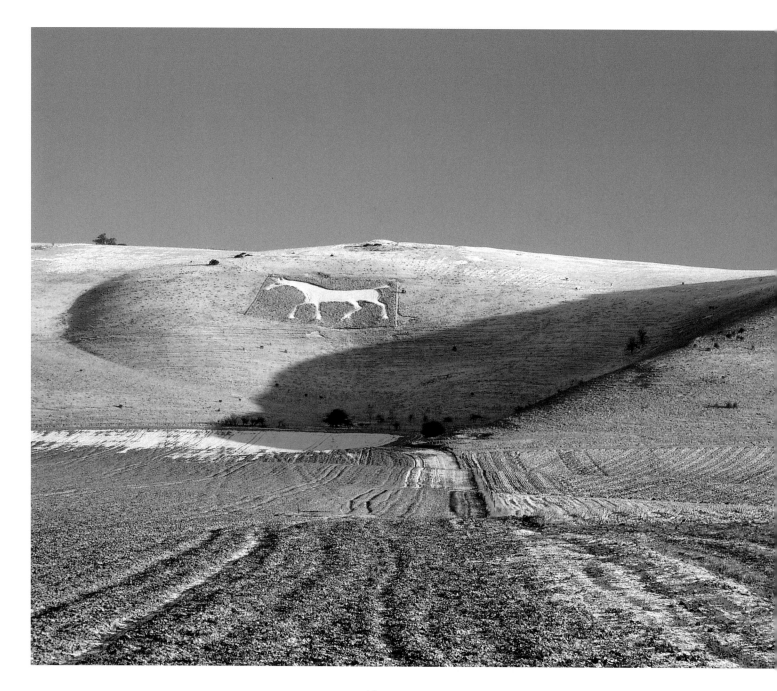

Ha, ese es el método.

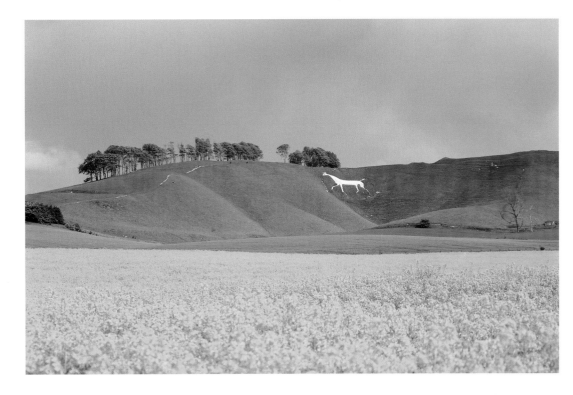

Above
The Cherhill White Horse
Dr Alsop stood at the viewpoint of this picture in 1780 and shouted instructions to his helpers through a megaphone. The result was a wonderfully jaunty horse.

Left
Alton Barnes White Horse
Wiltshire's White Horses are famed, and this one, the white enhanced by frost, can be seen from Old Sarum, some 30 miles to the south.

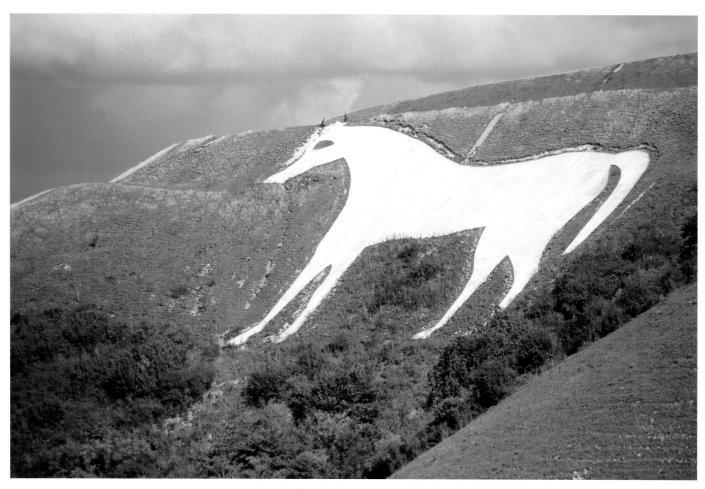

The Westbury White Horse
Some of these seemingly-ancient hill figures are only a couple of hundred years old.
This one's size is highlighted by the people gathered by its ears.

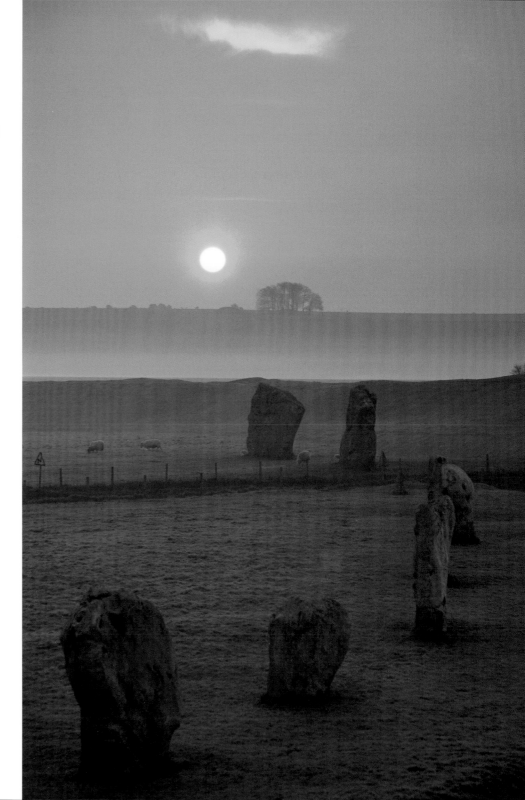

Avebury's Great Circle at dawn
Some of the stones will have witnessed
nearly one and a half million sunrises
and their great antiquity is absolutely
tangible in this scene.

13

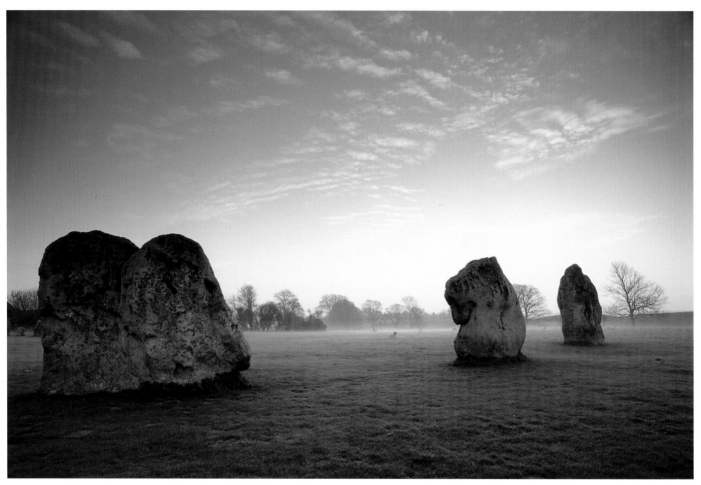

Southern Circle at daybreak
Avebury may give a more spiritual feeling than Stonehenge because you can wander
freely amongst the huge stones and, at dawn, be completely alone.

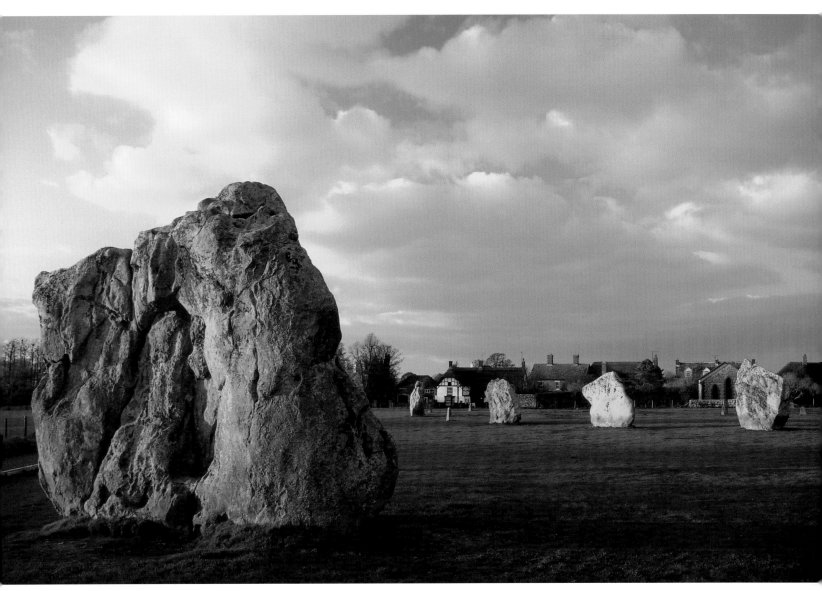

Avebury at sunset
Low winter light really brings out the features of the stones which envelop the village.
Quite a few of the stones were incorporated into the village buildings over the centuries, too.

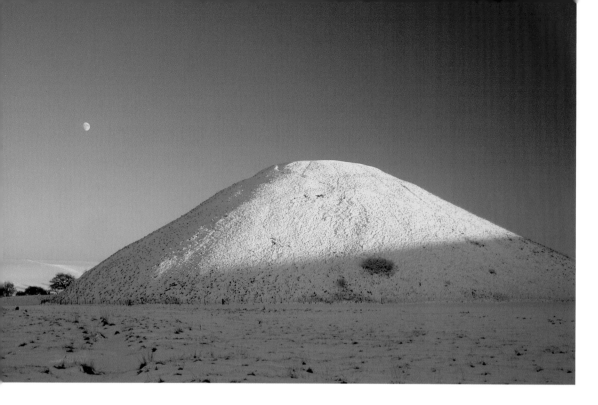

Silbury Hill at sunset
The largest man-made prehistoric construction in Europe looks even more mysterious under its soft blanket of snow. To this day, no-one knows why it was built.

Reflections
Silent and majestic, Silbury Hill sits in a short-lived, mirror-calm lake after severe floods.

16

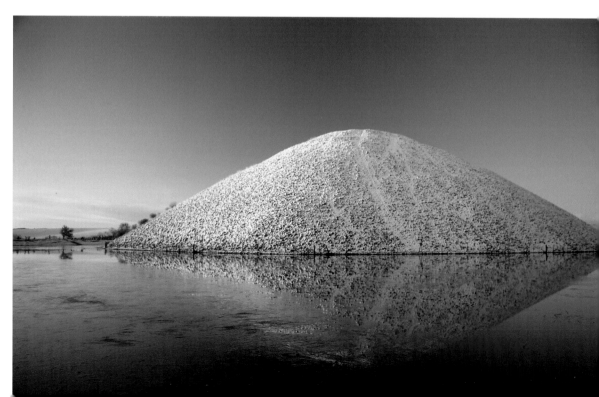

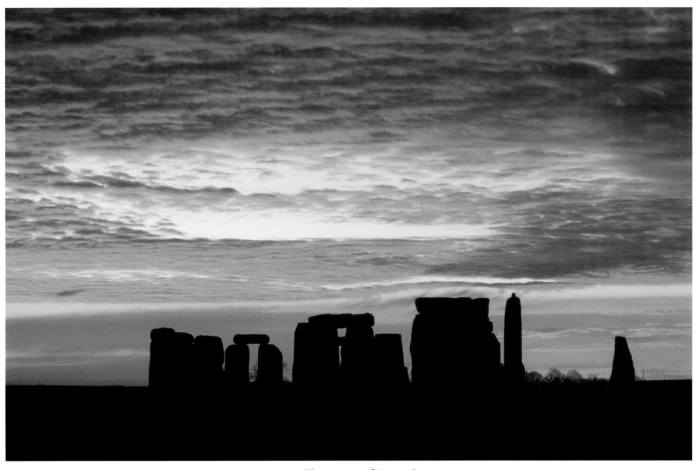

Sunset silhouette of Stonehenge
Four thousand years old, still incredibly mysterious and spiritual and, not surprisingly, a World Heritage Site.

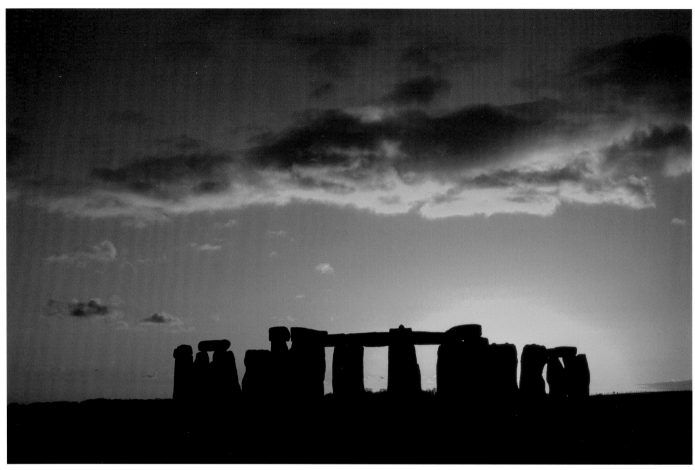

Awe-inspiring Stonehenge
Who can fail to be awe-inspired by the four-thousand-year-old henge under such a dramatic sunset?

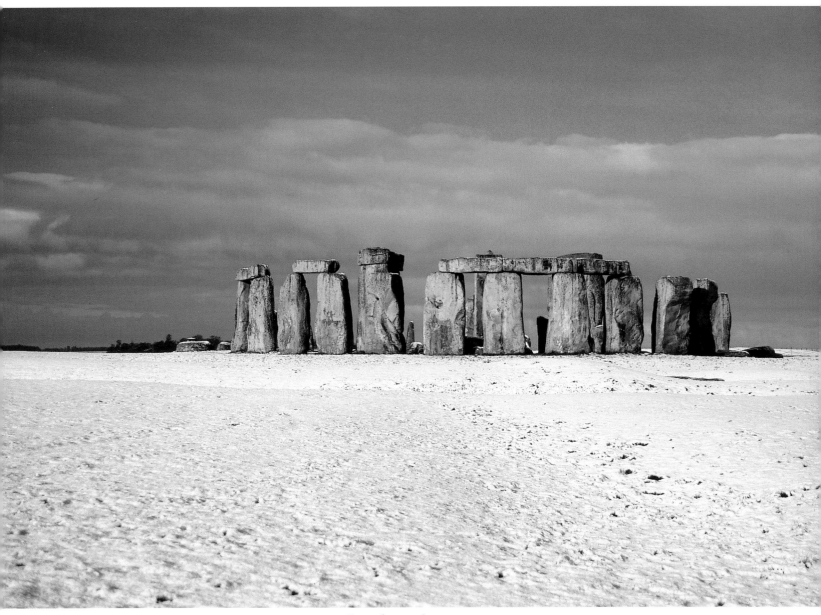

Stonehenge in snow
Spring snow casts a mysterious stillness over the scene and the stones appear huge and forbidding.

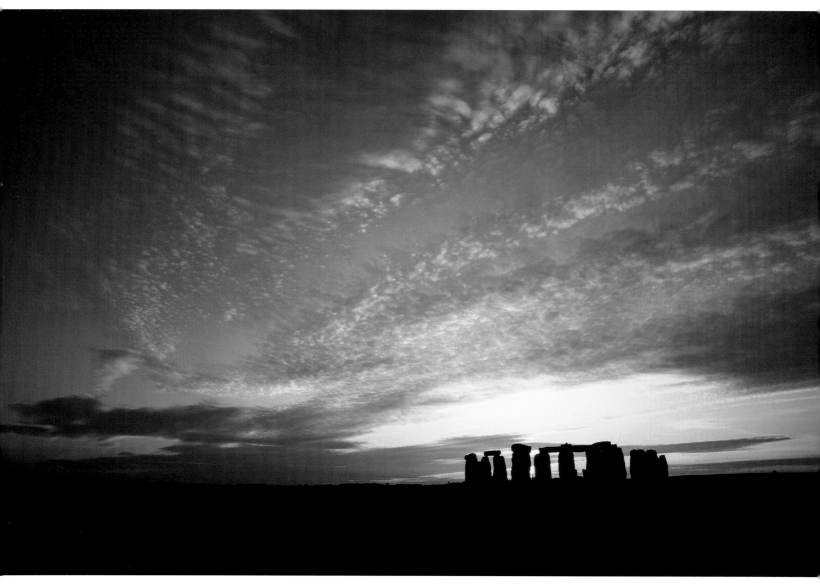

Man versus nature
Looking west during a cloud-veiled sunset, the unmistakable outline of the henge is dwarfed by a spectacular cloudscape.

Prehistoric stonemasons' handiwork
Natural sarsen stones contrast with the
laboriously-worked geometric trilothons.
It is awesome when you consider that
their shaping and raising was achieved
with such primitive technology.

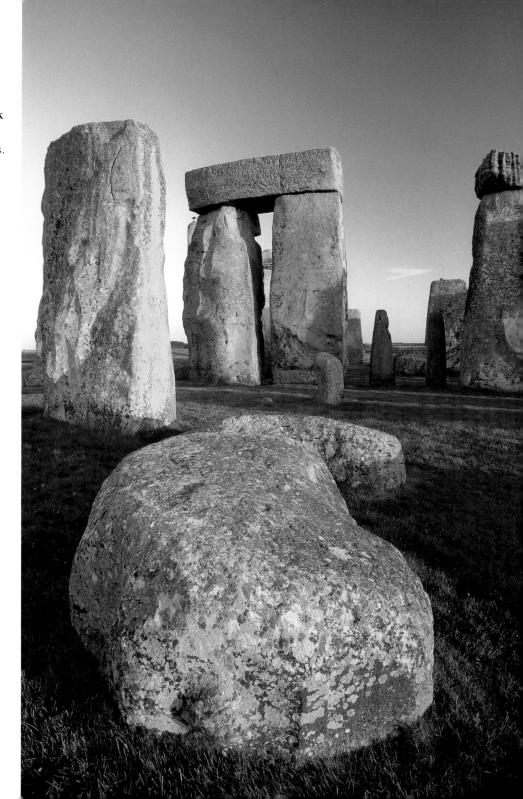

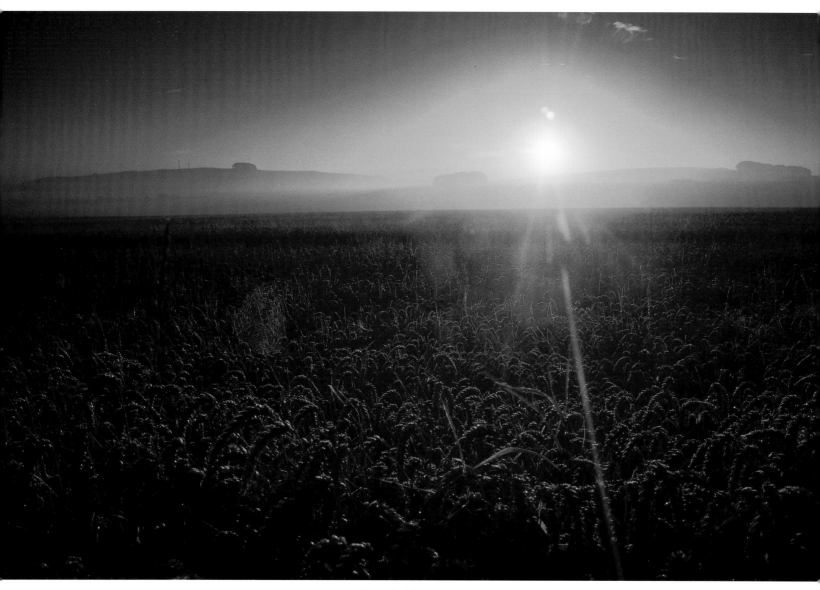

Wheatfield at sunrise
The downs with their characteristic beech clumps form the backdrop to a beautifully-lit farmland scene in Pewsey Vale.

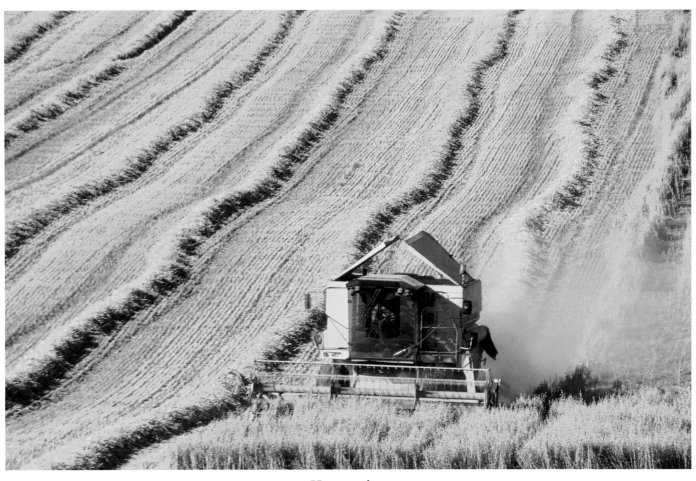

Harvest time
An almost monochrome study of the hot, dusty work of combine-harvesting.
Farming remains an important activity in the county.

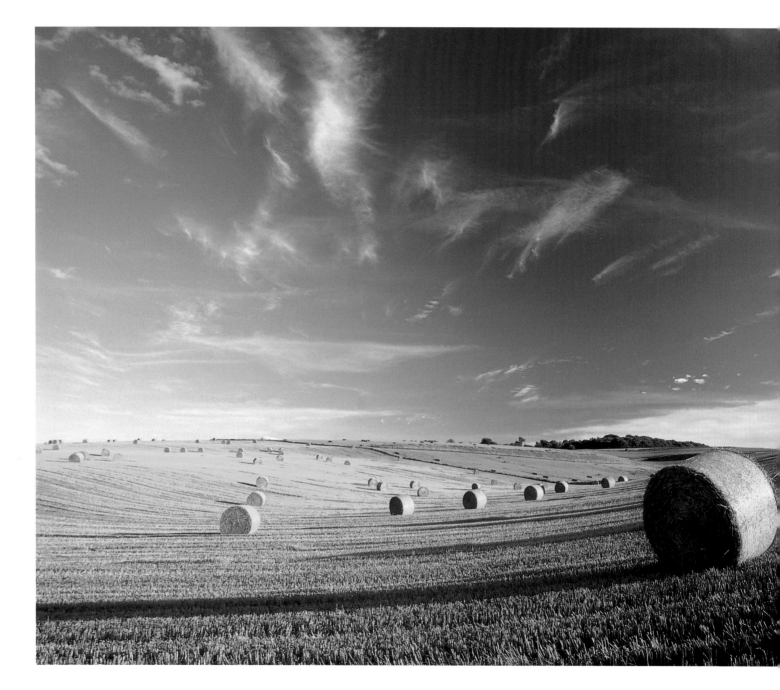

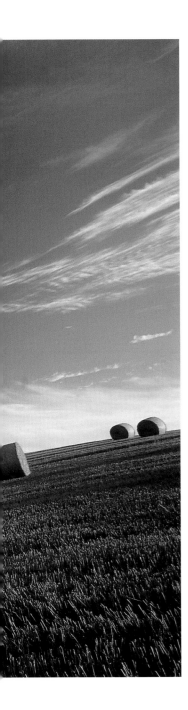

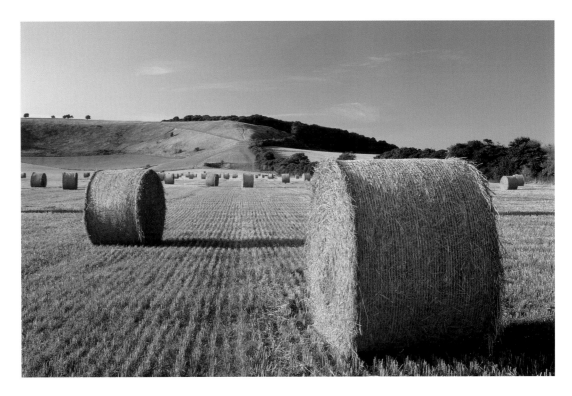

Above
An invitation to explore
The bales and croplines lead you to the start of a path,
inviting you up onto the downs beyond.

Left
After the harvest
The dramatic sky, with radiating clouds, accentuates the strong
sense of space in this typical Wiltshire scene, near Great Wishford.

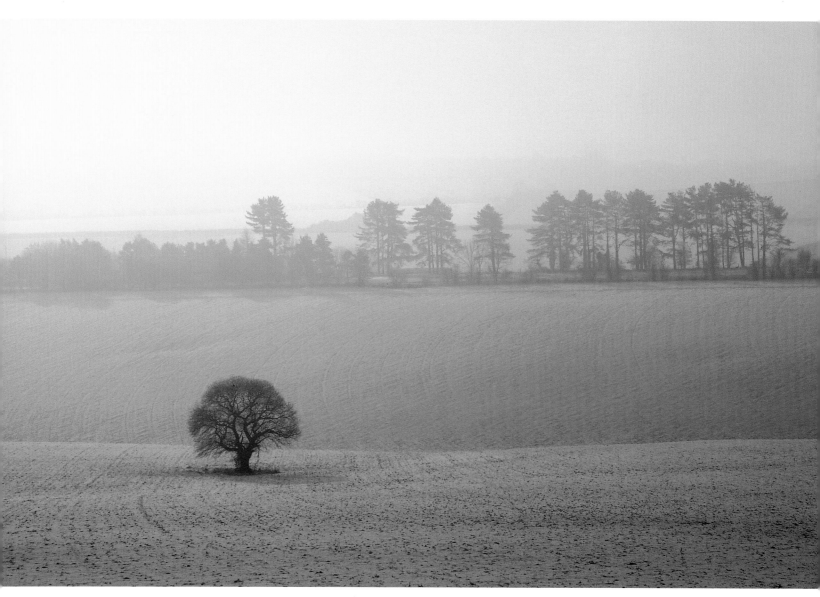

Horse chestnut in a winter landscape
Bare fields, bare tree, and a chill mist imbue this scene near Two Mile Down with the sadness of a cold, damp winter.

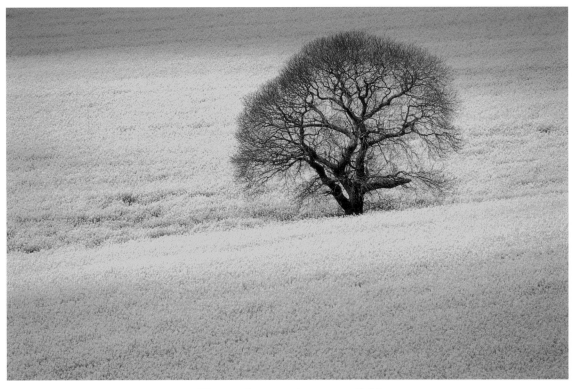

Horse chestnut in a rape field
The same bare tree, but now set in a rape field of gaudy canary yellow,
lifts the spirits with the promise of the coming of spring.

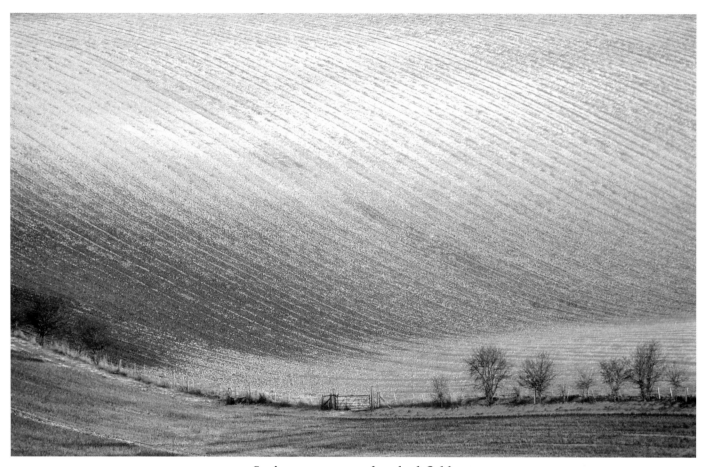

Spring snow on a ploughed field
Wiltshire is still essentially a rural county. The soft light lends an air of
melancholy to this simple farming scene at Stockton Down.

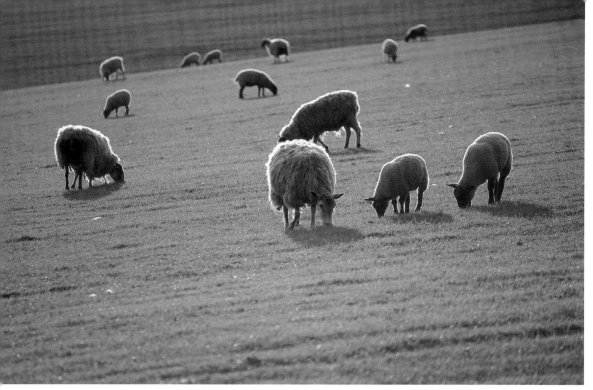

Backlit sheep
Grazing sheep have been a characteristic feature of Wiltshire for centuries.

Sheep and lambs at Littlecote House
Wiltshire without sheep is unimaginable. Their tremulous bleating accompanies you on almost any walk and it is thanks to them that downland turf is so short and wonderfully springy.

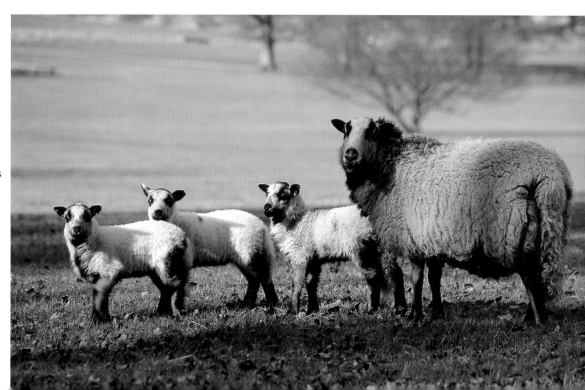

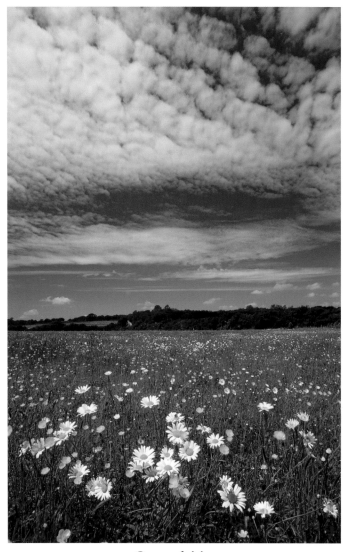

Oxeye daisies
Avis Meadow is a traditionally-managed hay meadow,
owned by Wiltshire Wildlife Trust. A carpet of tall
daisies delights the eye in mid summer.

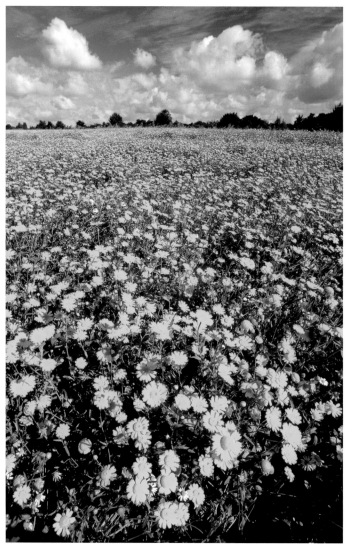

A blaze of summer colour
Wild corn marigolds, growing in profusion near
Salisbury, set off the perfect sky.

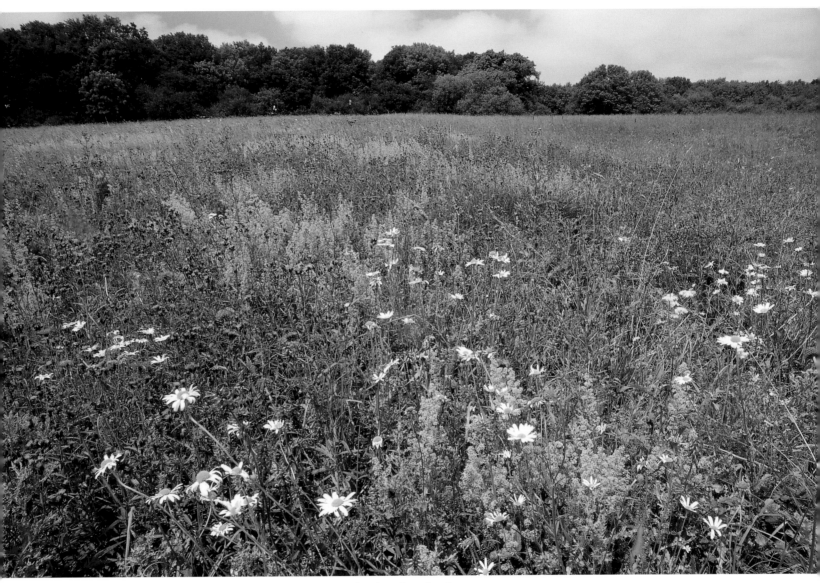

Step back a hundred years
Echo Lodge Meadows show us how much prettier and alive farmland used to look in years gone by.

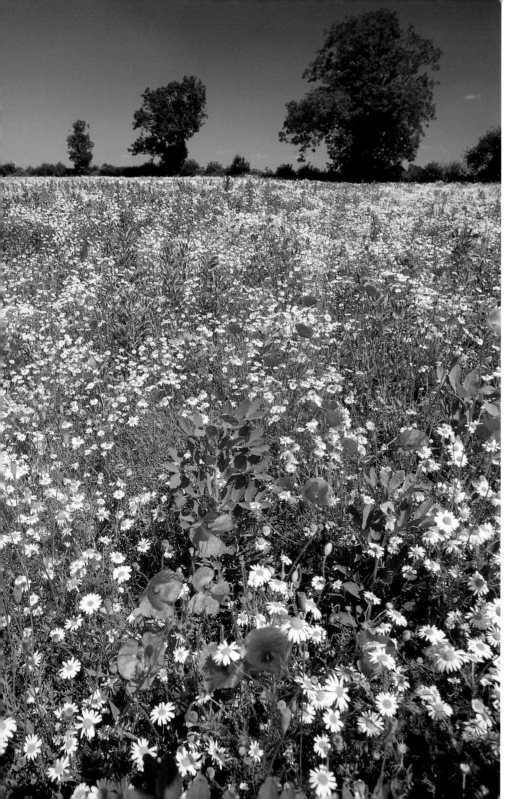

Set-aside in summer
Fast-growing annual flowers provide
a riot of colour as well as a home
for skylarks, voles and a hunting
ground for barn owls.

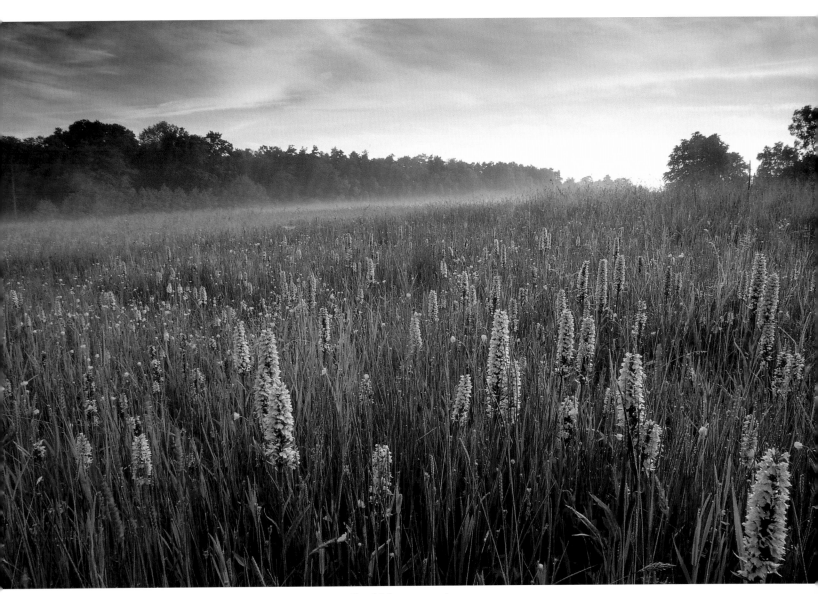

Orchids at sunrise

Soft dawn light captures the beauty of dew-laden common spotted
and southern marsh orchids in a damp meadow close to Salisbury.

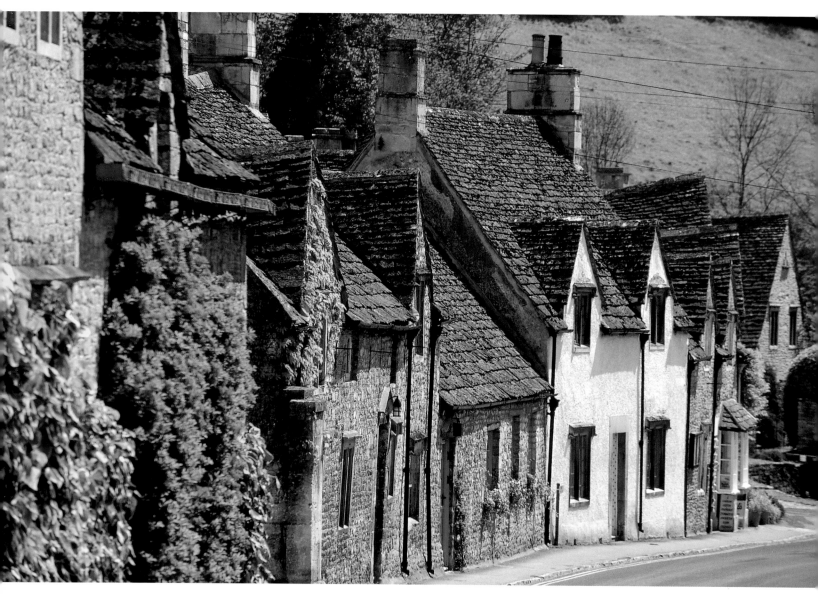

Harmony at Castle Combe

The village, with its buildings of mellow limestone, lies deep in a hanging valley in
north-west Wiltshire and is reputed to be one of the prettiest in England.

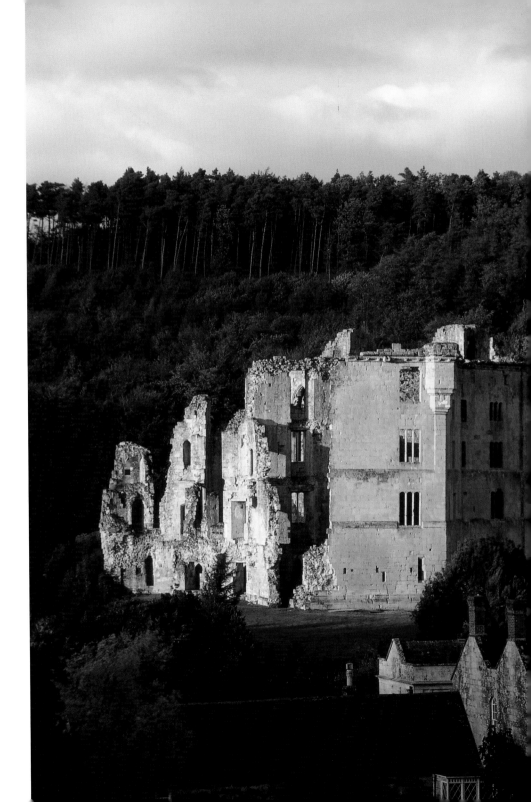

Old Wardour Castle
These impressive but austere ruins, set in woodland, are rendered more romantic by early morning light.

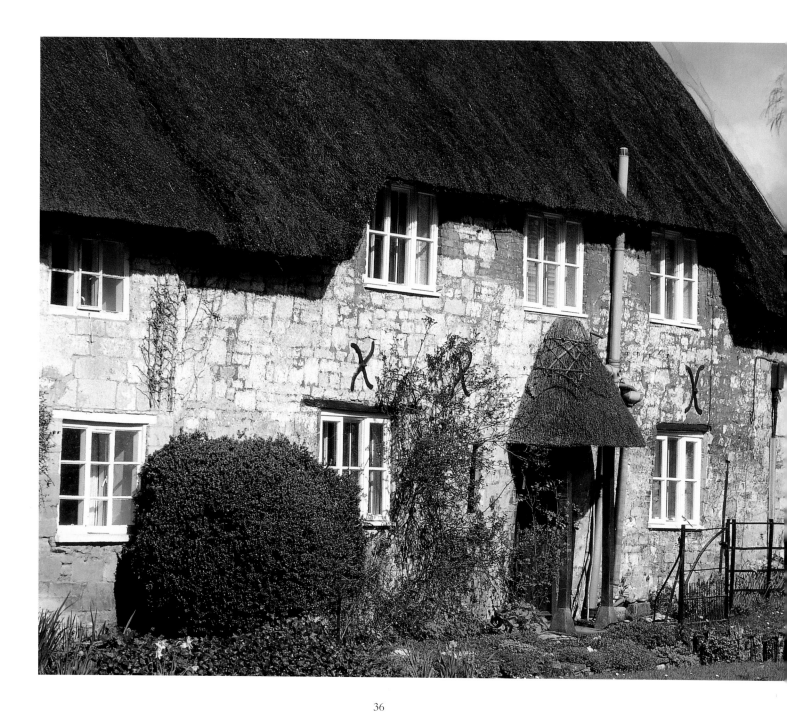

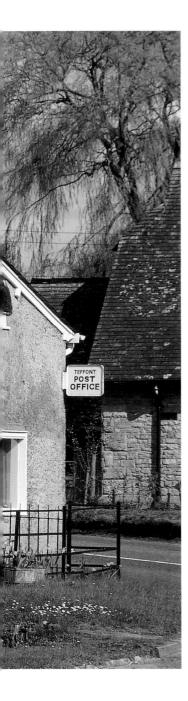

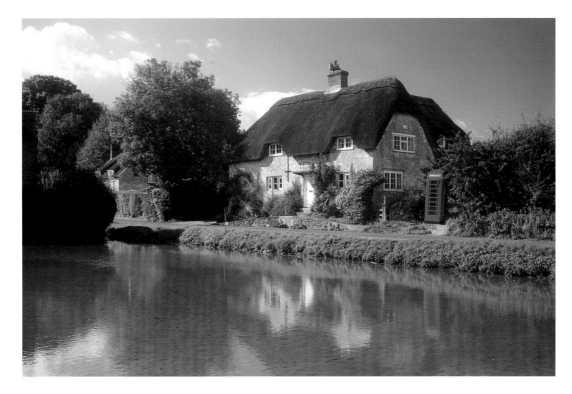

Above
In days gone by
A traditional red public phone box nestles next to an ancient cottage in Sherrington.
Remember when people weren't slaves to mobile phones?

Left
Thatched cottages at Teffont Magna
A crystal-clear trout stream flows past the doors of many
of the houses in this small, harmonious village.

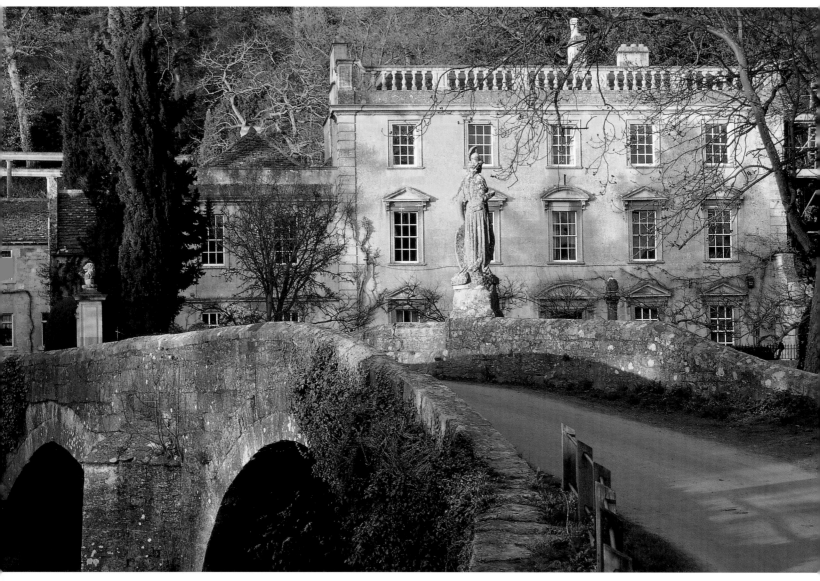

Mellow Bath stone
Iford Manor stands beside the River Frome in light that captures the beauty of the local stone.

A storm passes
A typical timber-framed brick cottage
bathes in gorgeous light as stormy skies
retreat from Steeple Ashton.

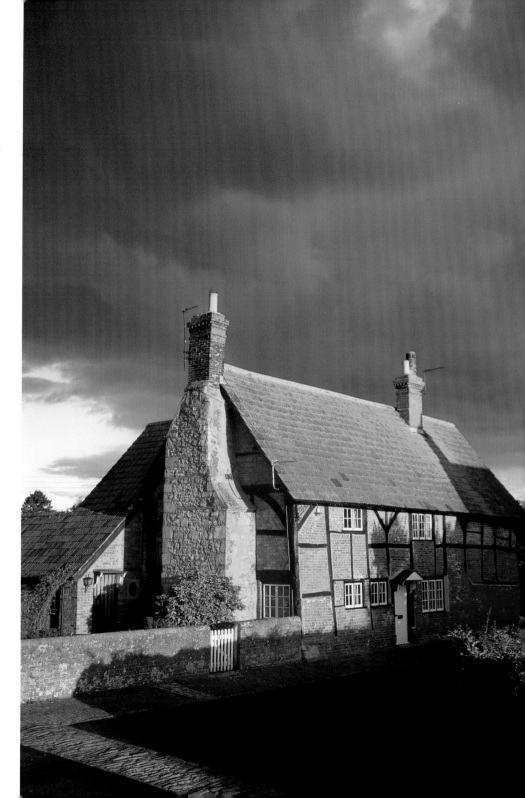

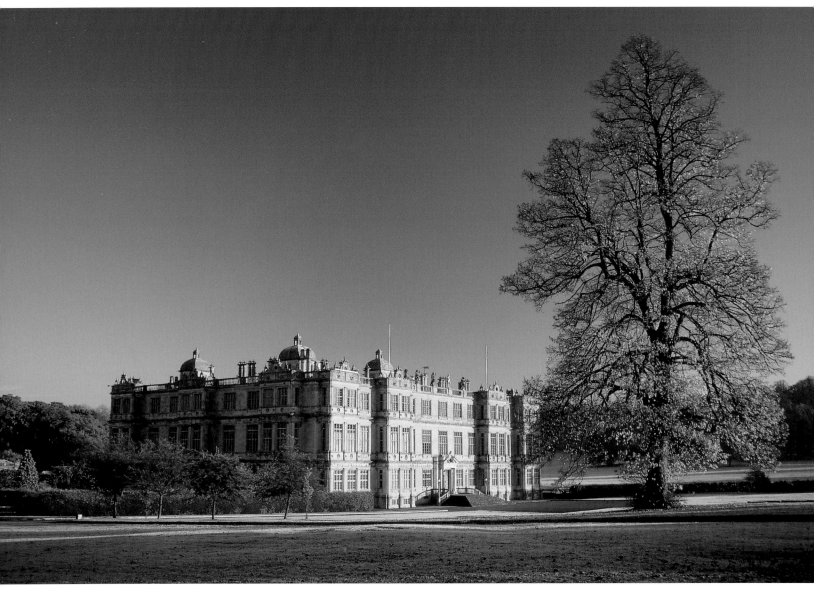

Longleat in autumn
The grandiose five-hundred-year-old house is set in parkland and thousands of acres of woodland.

Teffont Evias in its valley
Light takes a while to reach into the
valley in winter and first strikes the
steeple of St Michael and All Angels
and the turret of the Manor House.

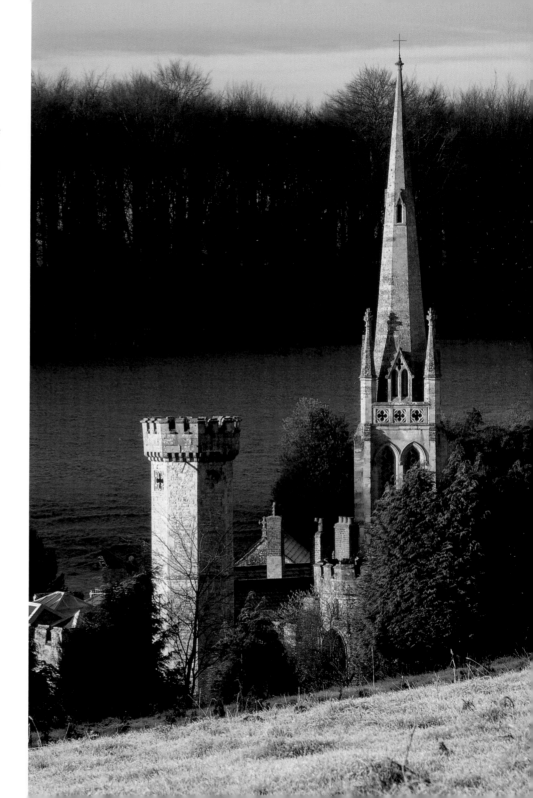

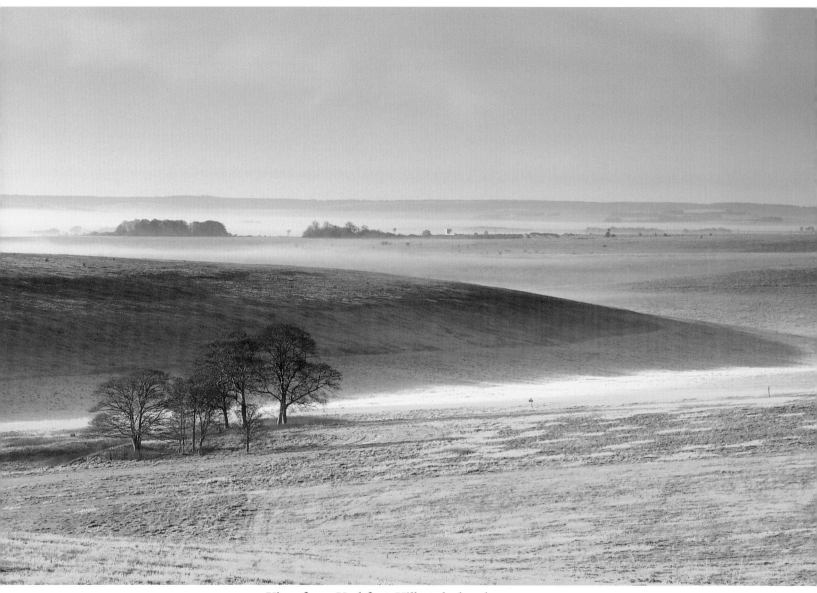

View from Urchfont Hill at daybreak

Salisbury Plain escarpment on a cold November morning. A vast area of Salisbury Plain has been in military possession since the turn of the twentieth century and this has preserved its character and wildlife.

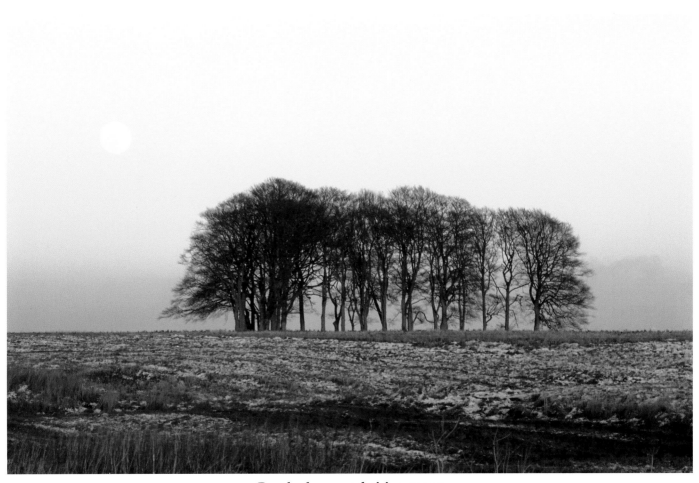

Beech clump and rising moon
A huge, silvery full moon hangs next to the beech clump near
Market Lavington, high on Salisbury Plain Training Area.

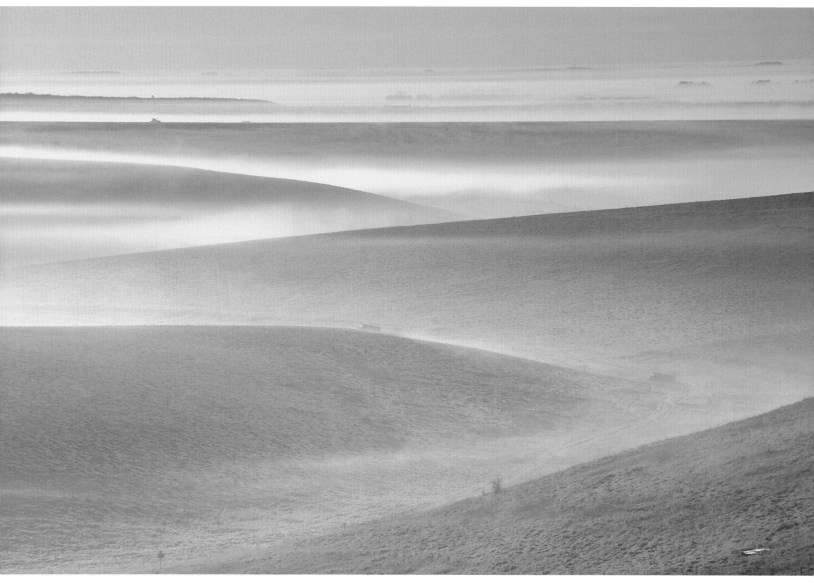

November dawn on Salisbury Plain
High ground and woodland peek up out of the valley mists in this enormous, rolling wilderness.

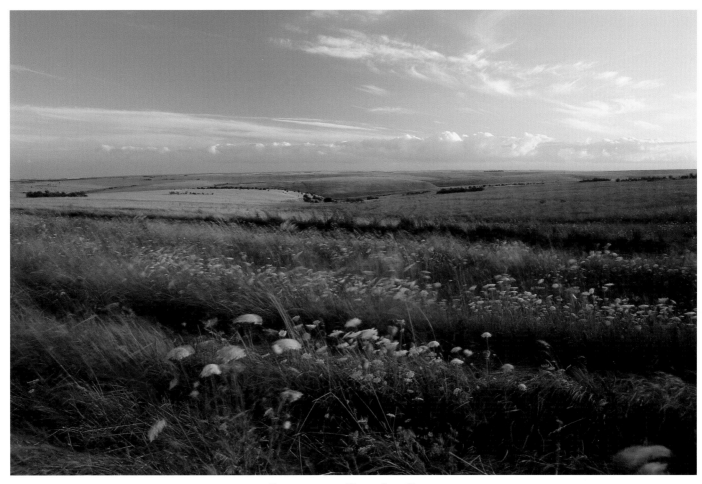

Sunset near Casterley Camp

Huge vistas that go on forever, and a wind that blows unhindered across the vast, empty chalk plateau of Salisbury Plain.

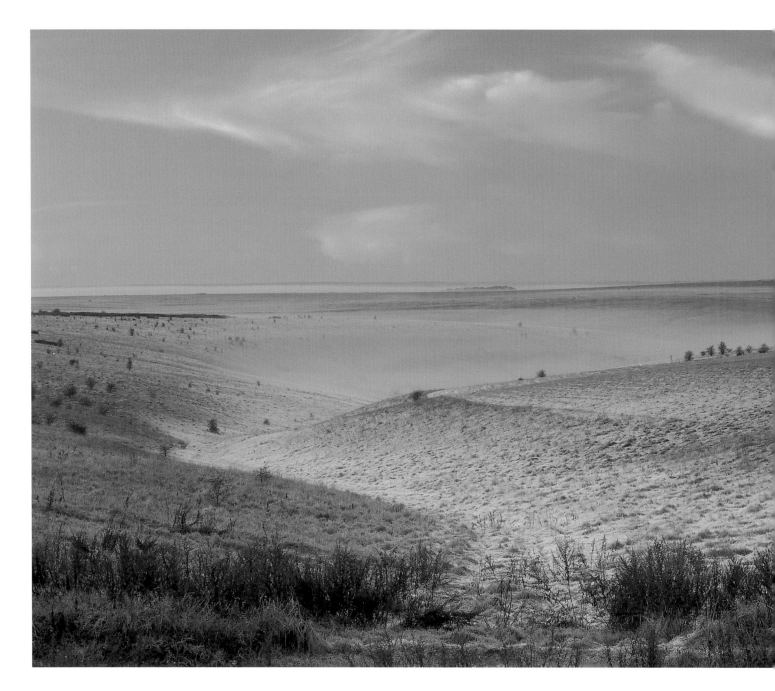

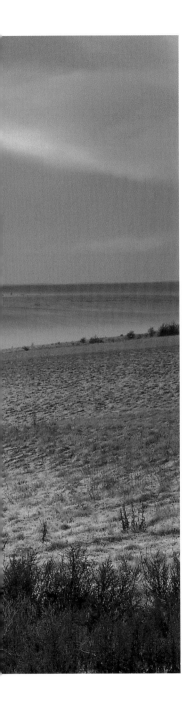

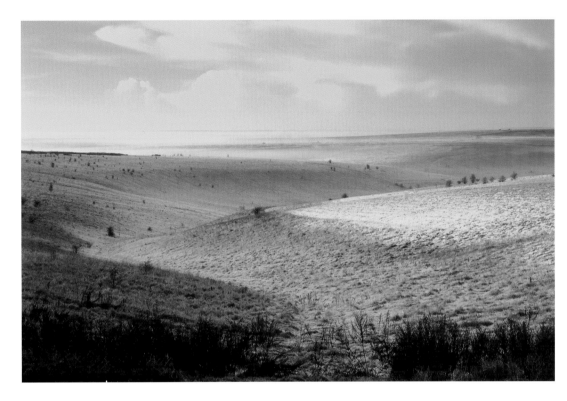

Left
Dawn breaks near Rushall Down...
The first rays of the sun touch the base of the clouds, frost lies in
the hollows and the land is a canvas of muted colours.

Above
...and minutes later
The sun rises higher and starts to bathe the cold November scene in golden light.

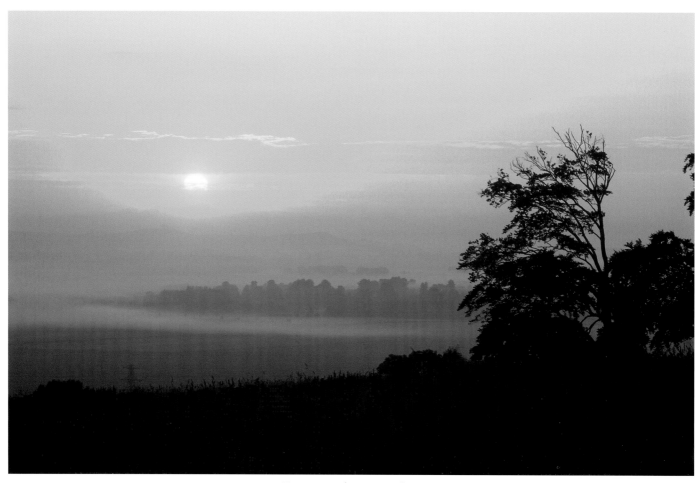

Pewsey Vale at sunrise
Seen from the edge of Salisbury Plain, the Vale is partially hidden in the mists.

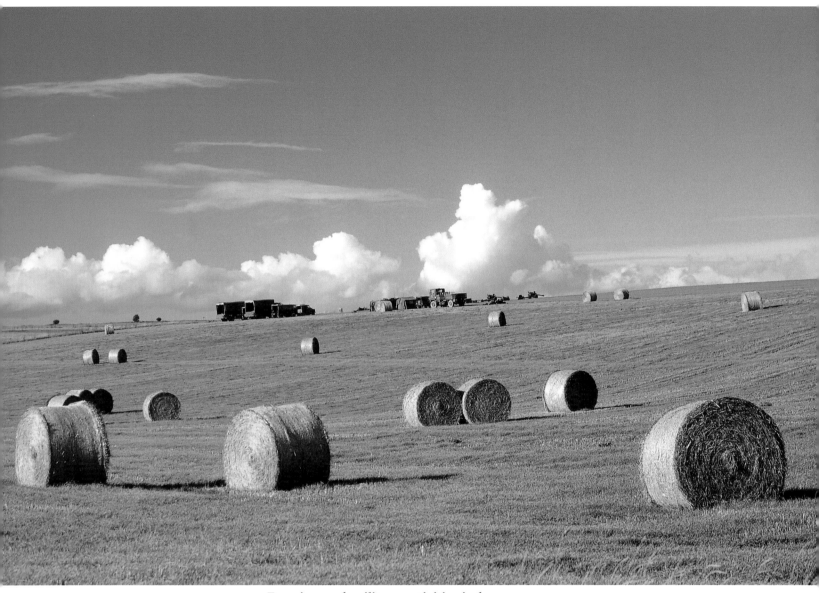

Farming and military activities in harmony
Salisbury Plain Training Area under a huge sky on a lovely sunny day.
The Military allows considerable public access when they aren't engaged in exercises.

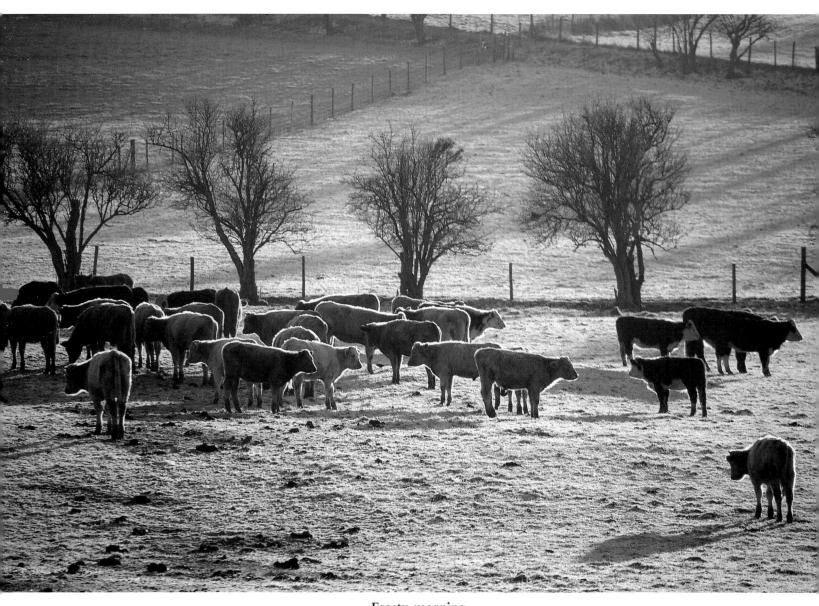

Frosty morning
Bullocks huddle for warmth and await their breakfast after a cold night near Chitterne.

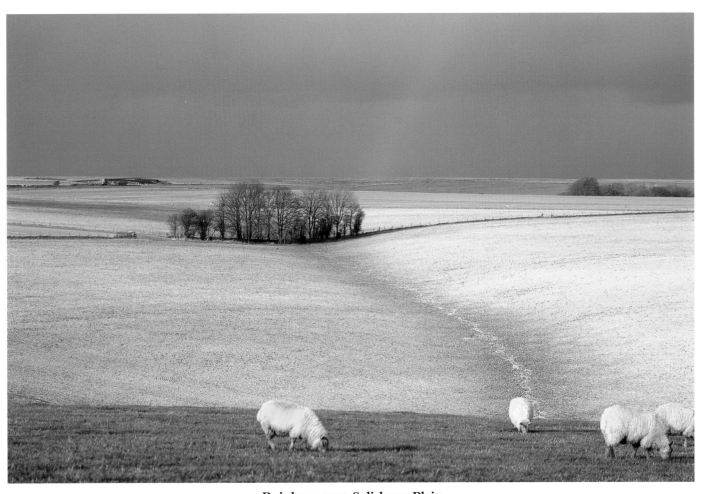

Rainbow over Salisbury Plain
Sheep grazing near Chitterne are oblivious to the rainbow that marks the passing of a storm.

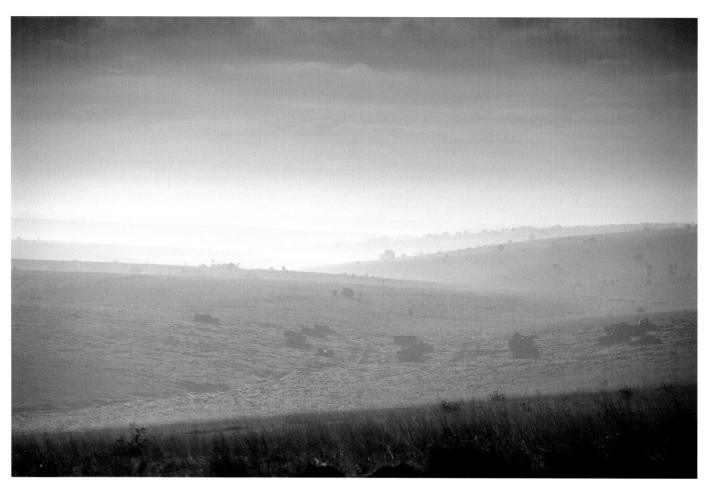

Honeydown Bottom
Mist shrouds distant target tanks on the Larkhill artillery range and
successive folds of downland stretch to the distant horizon.

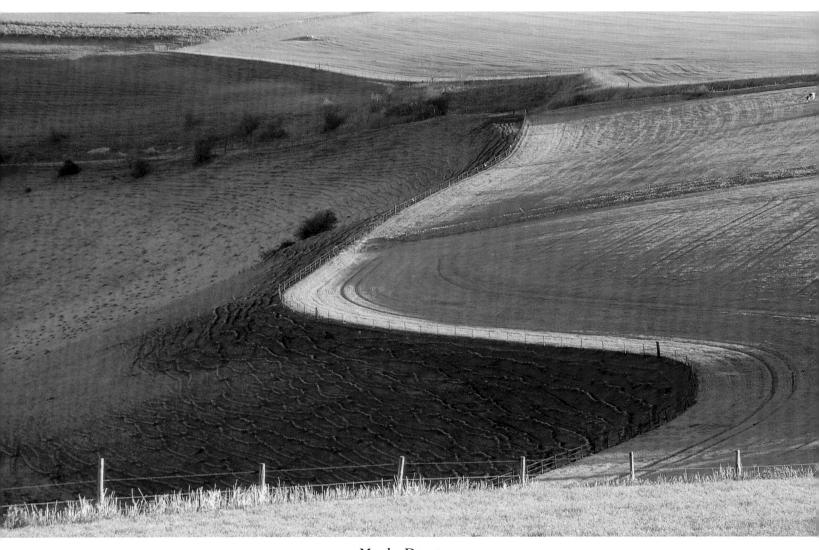

Monks Down
Light catches the top of the down and leads your eye across the scene. Many of the rounded summits
of the downs have been turned to agriculture, while the steep sides can only be grazed.

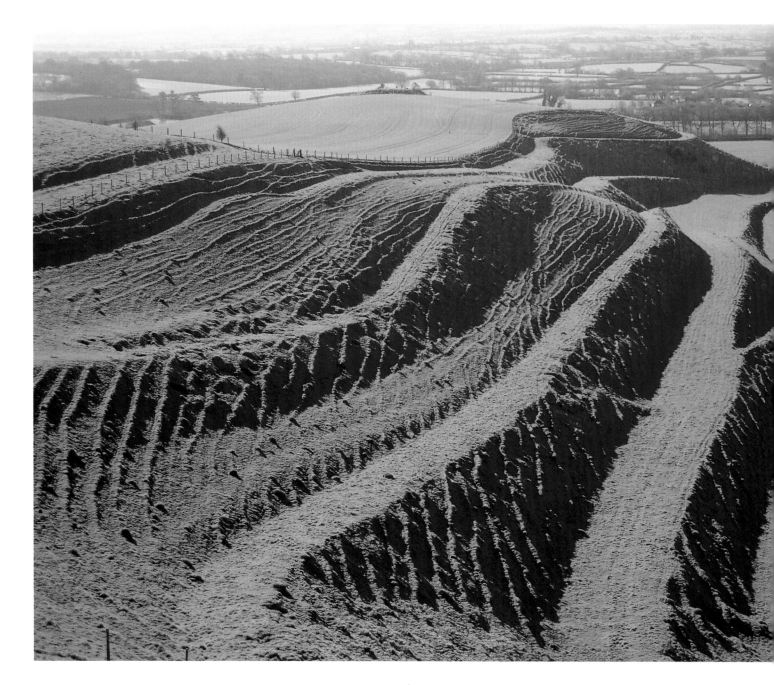

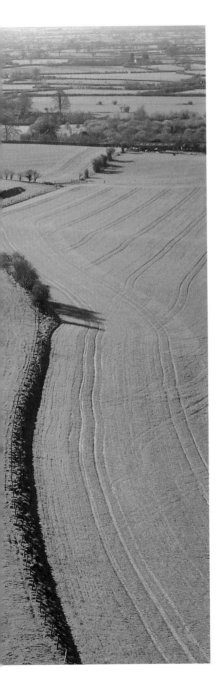

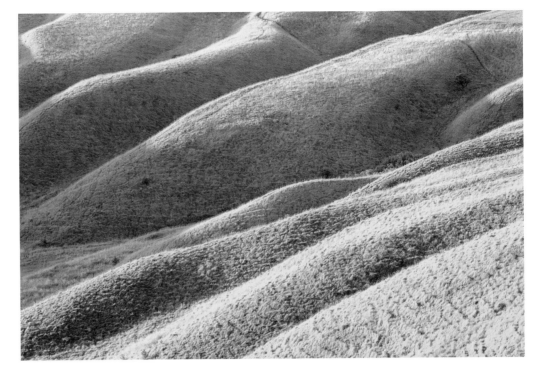

Above
Whalebacks at Roundway Down
Light picks out natural erosion gullies, sculpted into the fantastic curved
whalebacks so characteristic of downland landscapes.

Left
Strip lynchets at Mere Down
The side-lighting beautifully throws into relief the old system of farming
steep downs, using terraces linked to each other by small paths.

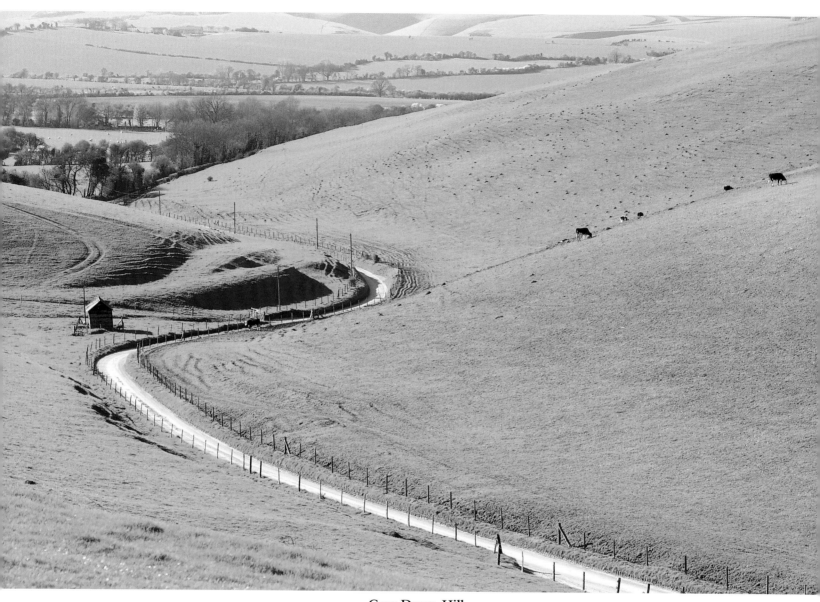

Cow Down Hill
Your eye is led down the tiny Misselfore and Bowerchalke road, as it snakes through
unspoiled downland, rich in prehistoric earthworks and Celtic field systems.

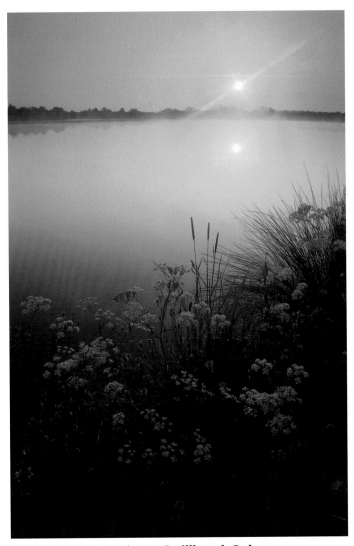

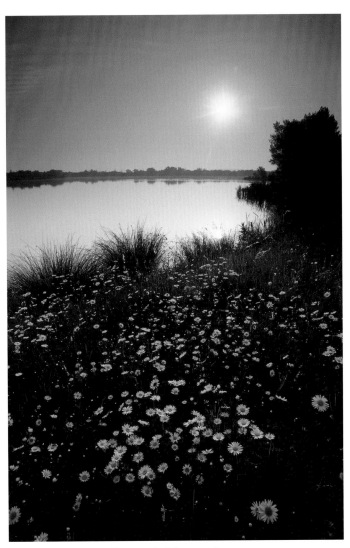

Sunrise at Swillbrook Lake
There is a dream-like quality to this scene,
and you can sense the still calm.

Oxeye daisies at dawn
Different weather and time of year give this
picture another atmosphere, with the lake
silver under a clear blue sky.

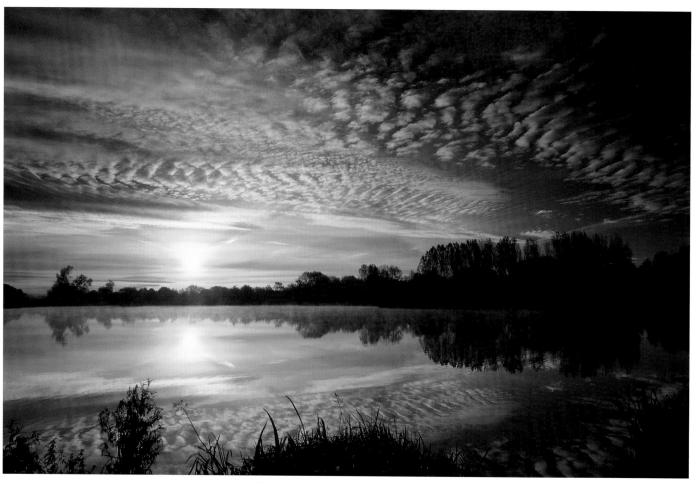

Cloudscape at Langford Lakes
A perfect, still dawn creates wonderful reflections on White Bird Lake.
The merest whisper of wind would have spoiled the composition of the picture.

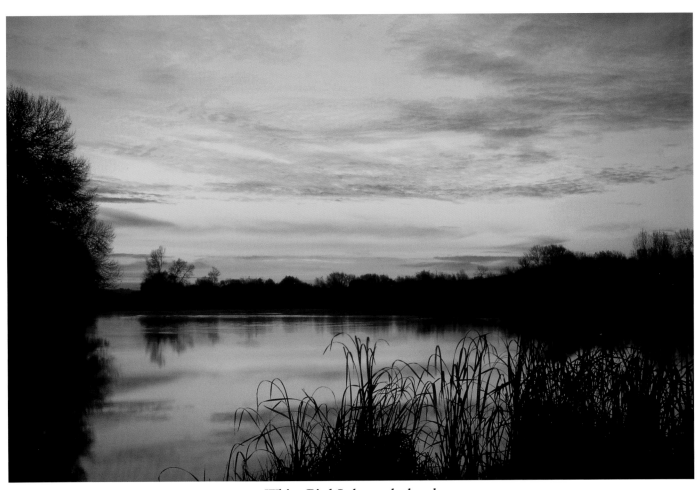

White Bird Lake at daybreak
A windless, gorgeous day dawns under a mackerel sky. Skies can make or break a picture.

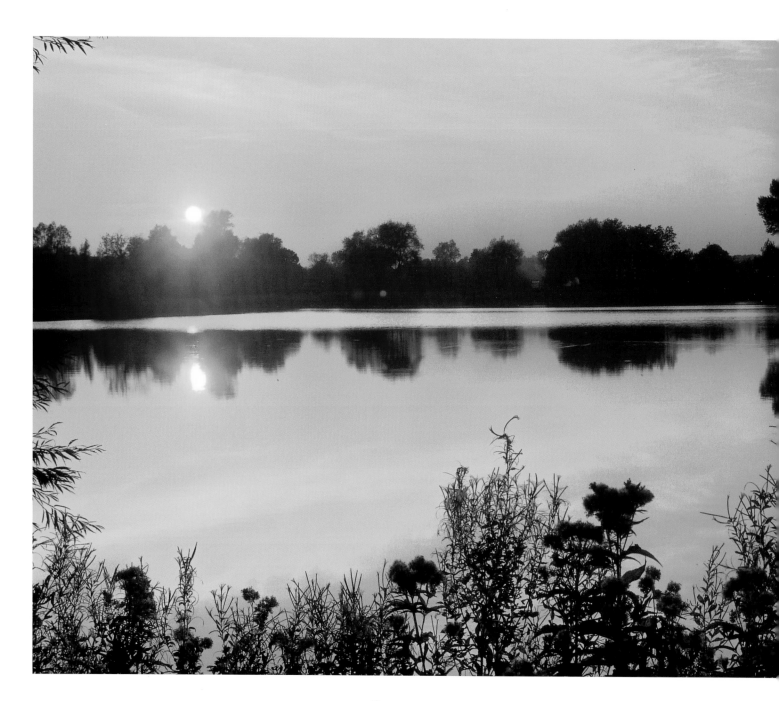

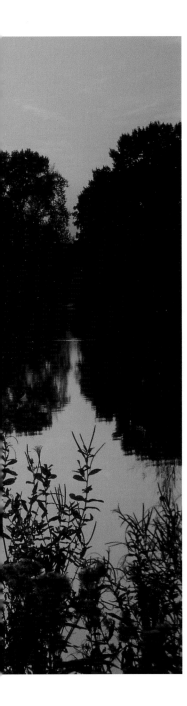

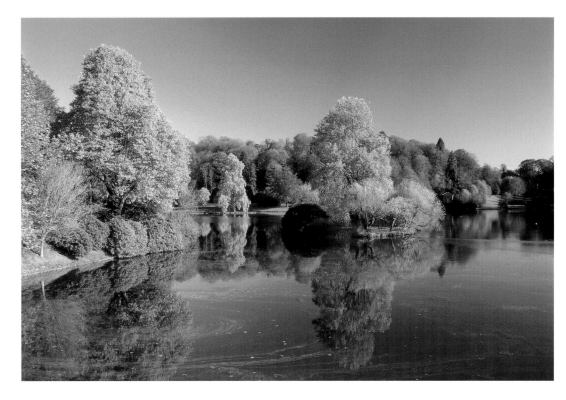

Above
Autumn magic at Stourhead
A composition with colours that take your breath away, in a scene created many
generations ago by the Hoare family, incredibly far-sighted garden designers.

Left
Sunset at White Bird Lake
The day ended with just the sound of ducks settling for the night.
Not a breath of wind, just clouds set against a golden sunset.

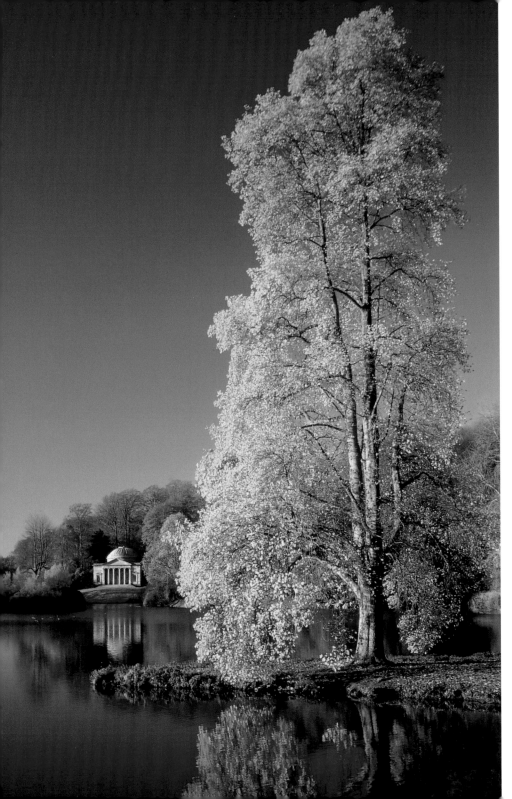

Tulip tree at Stourhead
Take an early morning stroll around the magnificent lake in autumn when the peace and the beauty are unforgettable.

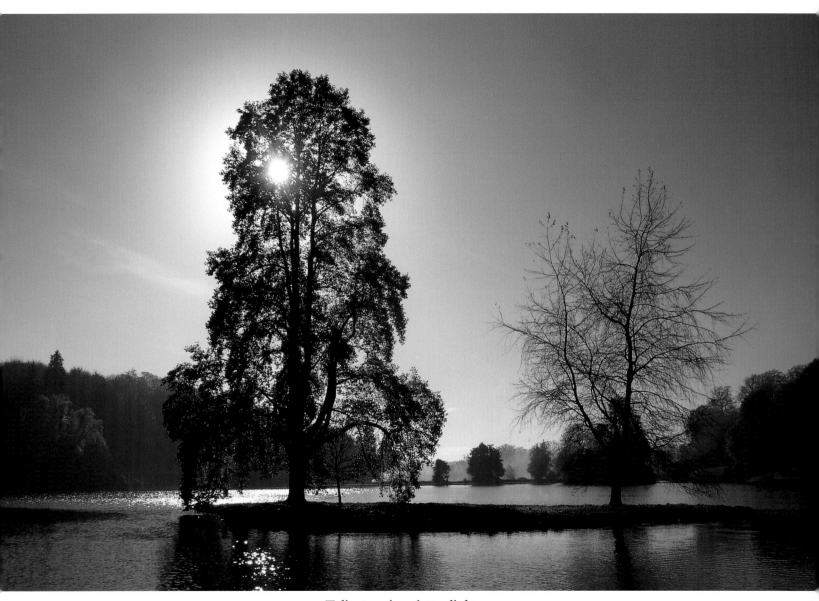

Tulip tree in winter light
A winter visit rewards you with a startlingly different but no less beautiful view.

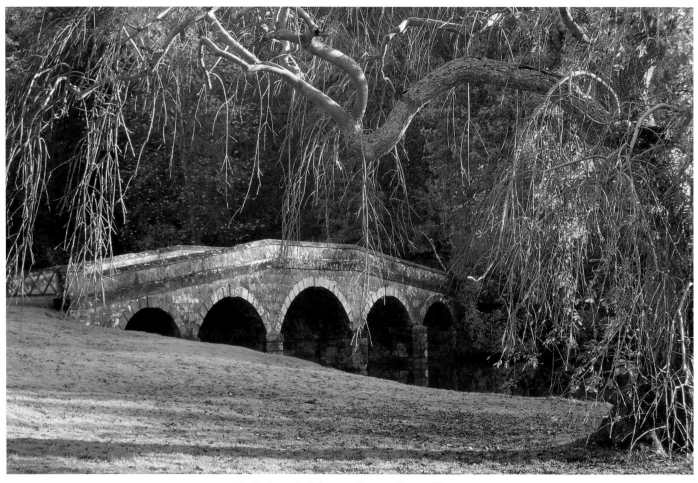

Palladian bridge and weeping willow
Early morning sun paints this picture with soft light and the tree exquisitely frames the Palladian-style bridge at Stourhead.

Shear Water in October
The two-hundred-year-old man-made
lake is surrounded by dense woodland
with magnificent veteran trees and
numerous paths to wander along.

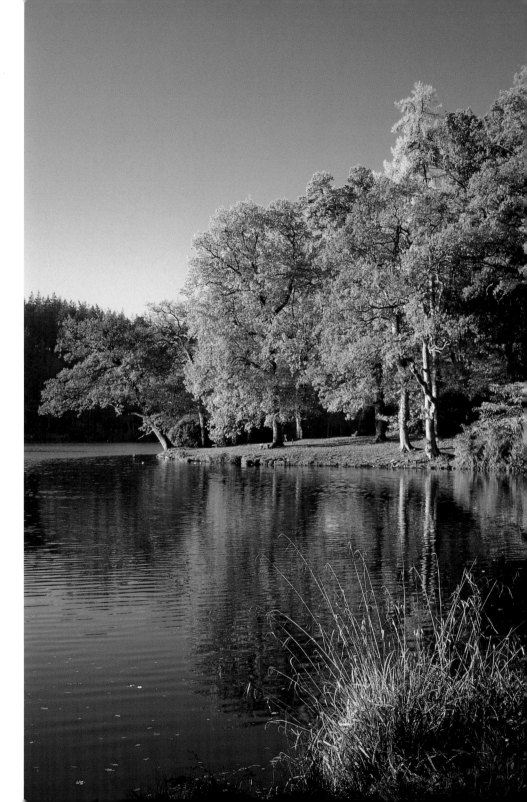

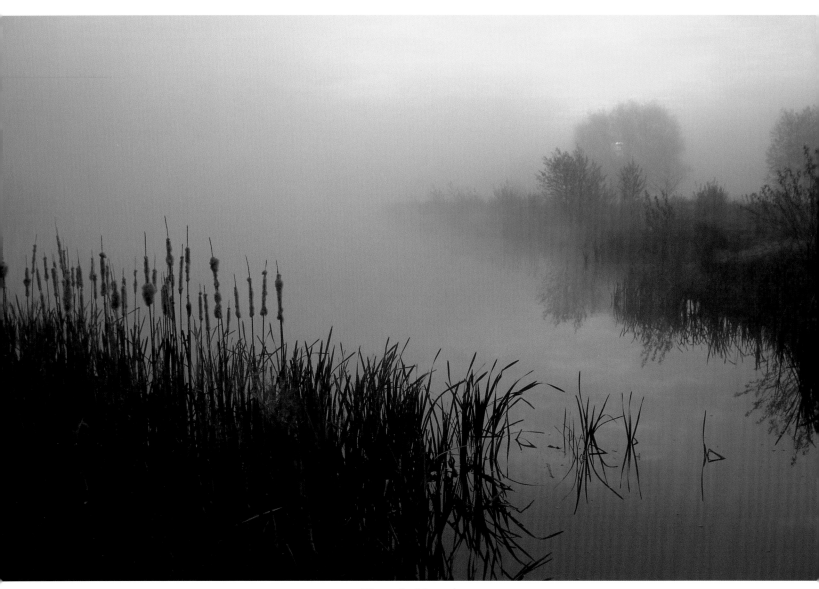

Shrouded in mist

Waterhay gravel pit, near Cricklade, waits patiently under a thick cloak of mist.
The foreground water channel catches your eye and leads it back into the picture.

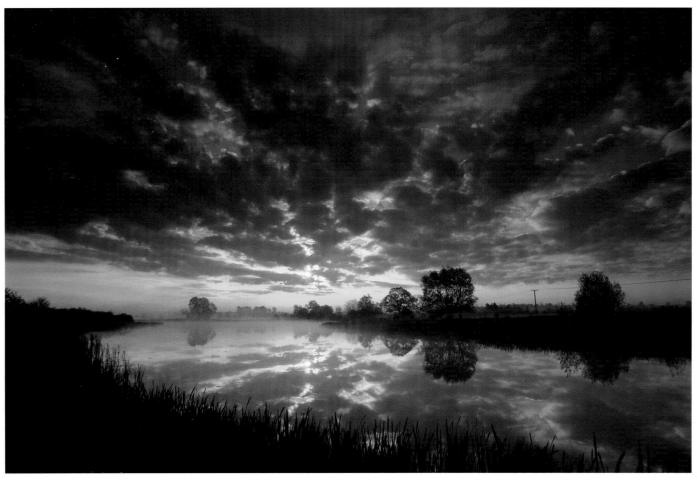

Waterhay cloudscape
The day breaks under a truly magnificent, dynamic sky and the utter
stillness allows the scene to be perfectly mirrored in the lake.

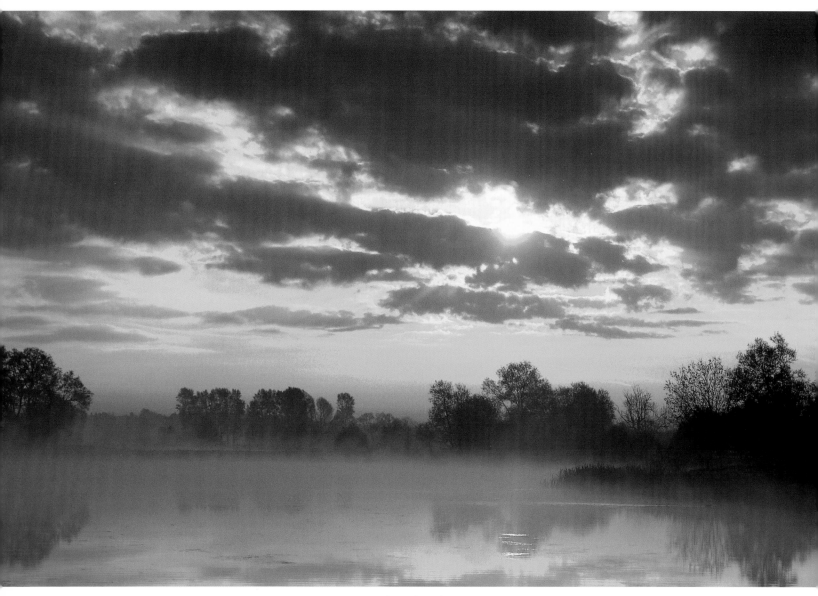

Another day dawns
Winter cold produces a misty blanket over Waterhay. Such scenes are
fleeting as the sun rises and breaks through to melt the mist away.

**Snakeshead fritillaries
at Upper Waterhay**
Once a common sight in riverside
meadows, fritillaries are now rare.
North Wiltshire has some 80%
of those remaining in Britain.

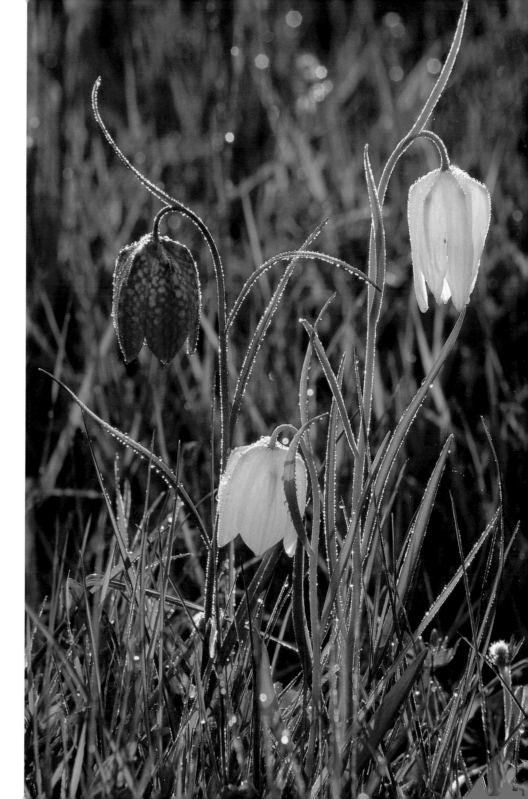

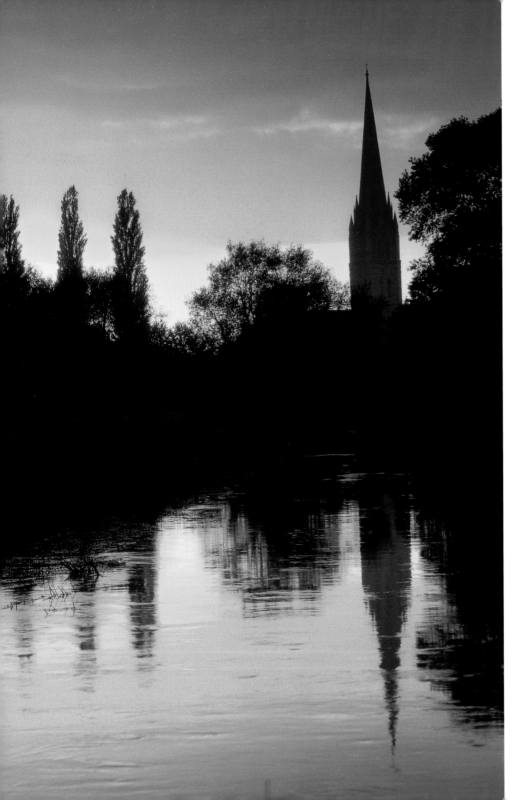

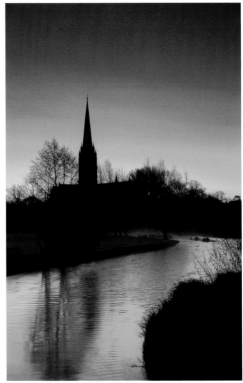

Above
Cathedral from the west
The Nadder is one of Salisbury's
five rivers. A slow shutter speed gave
the river a glassy sheen, under a
glorious red–washed dawn sky.

Left
The spire reflected
Salisbury cathedral's spire is reflected
in a River Avon turned to molten gold
by the most amazing sunset.

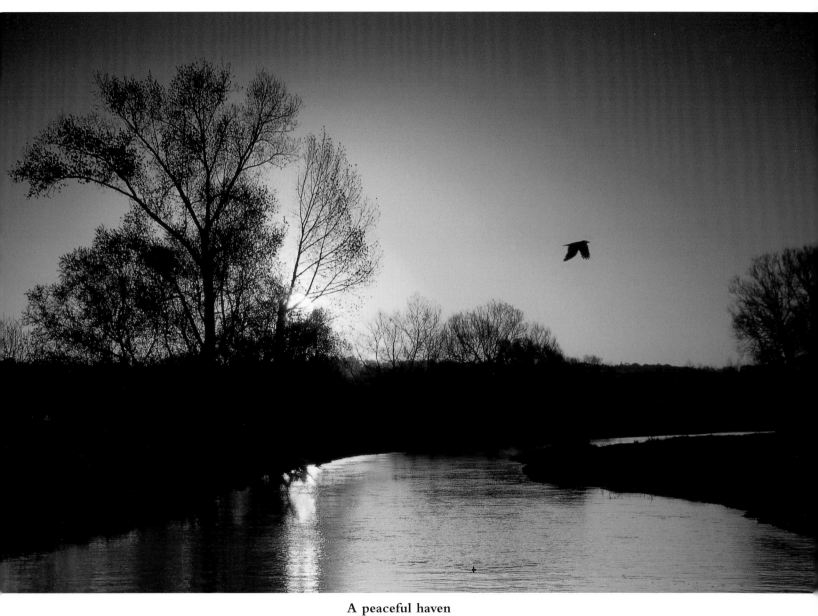

A peaceful haven
The Avon meanders through the water meadows, just a short walk from the city centre.

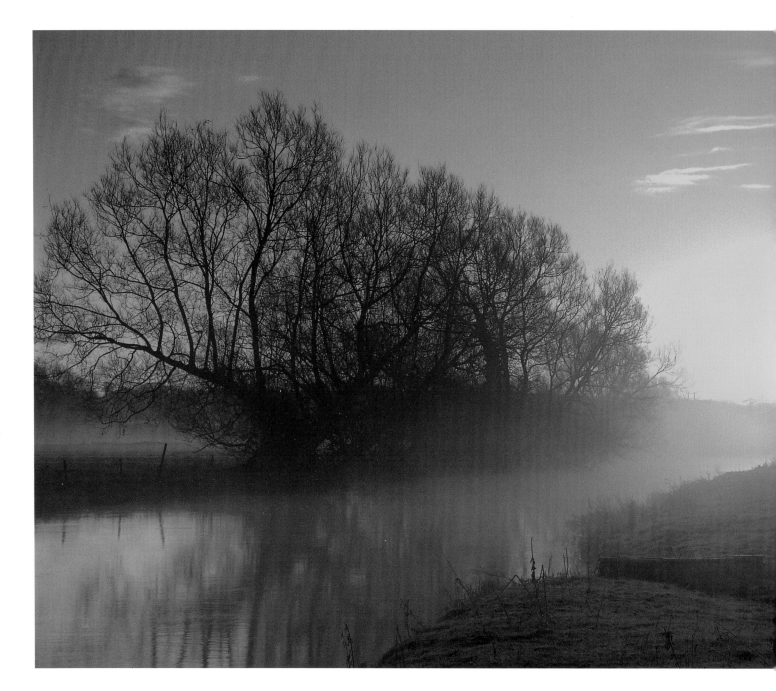

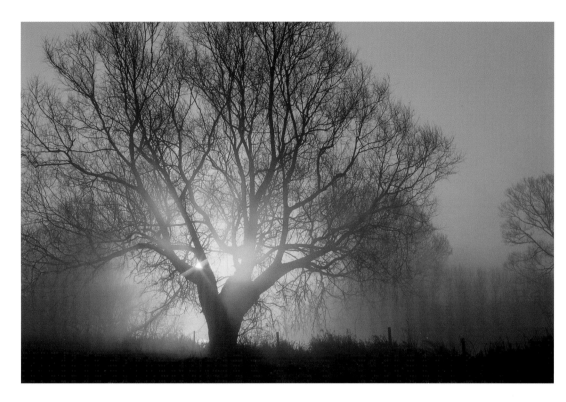

Above
Sunburst
The distinctive outline of a willow, so characteristic of river banks
throughout the county, is given a fiery halo by the rising sun.

Left
East Harnham water meadows
Mist cloaks the River Avon at dawn and creates an air of stillness
and mystery as your eye is led back to the rising sun.

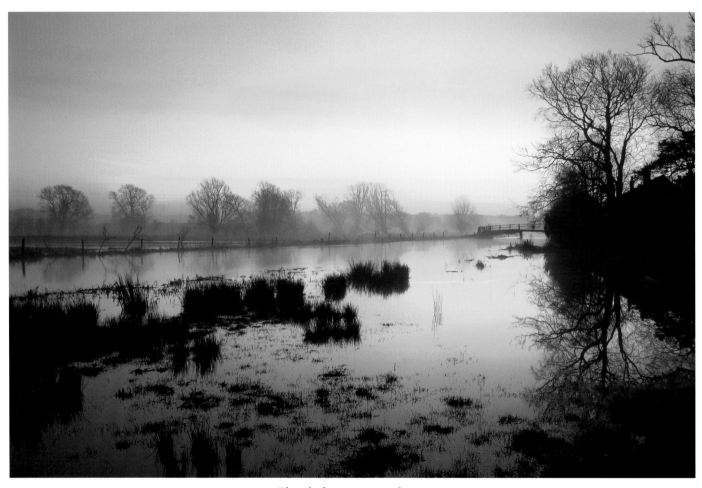

Flooded water meadows

The water meadows provide an utterly unique, but fragile, setting for Salisbury, lying both to their east and west.

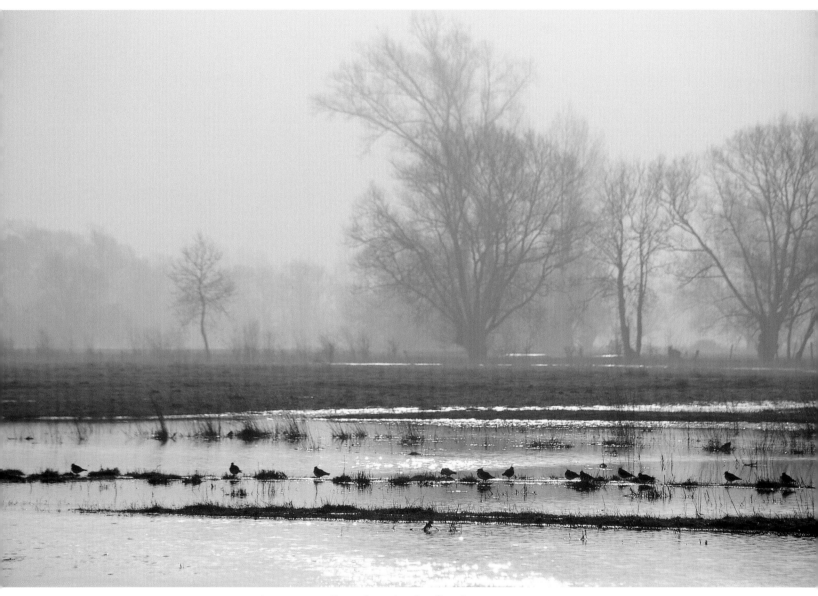

Lapwings in the floods
The water meadows sometimes flood in winter, attracting lapwings, with their mournful 'pee-wit' cry.

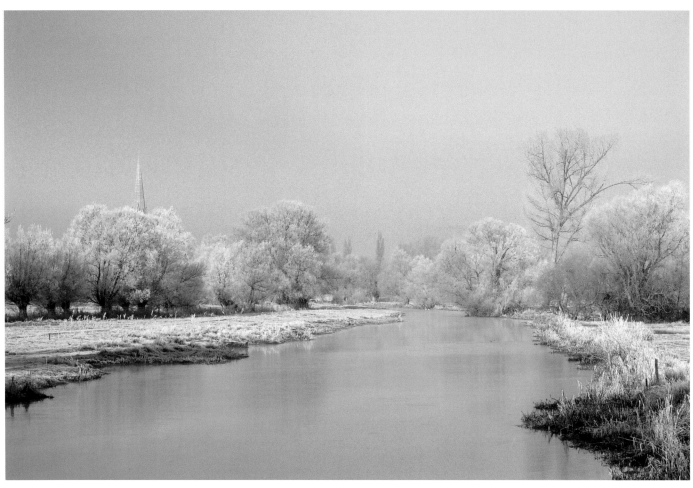

Bitter cold beauty
A severe hoar frost had coated everything with white ice crystals.
The cold is tangible and remnants of a thick, freezing fog lingered to soften the light.

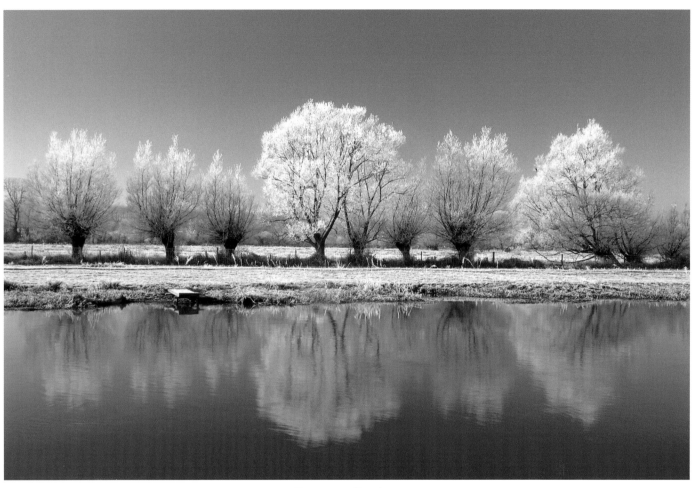

Frozen reflections

The fog cleared, leaving a brilliant blue sky, but the scene was very short-lived as the sun rose higher and melted the ice.

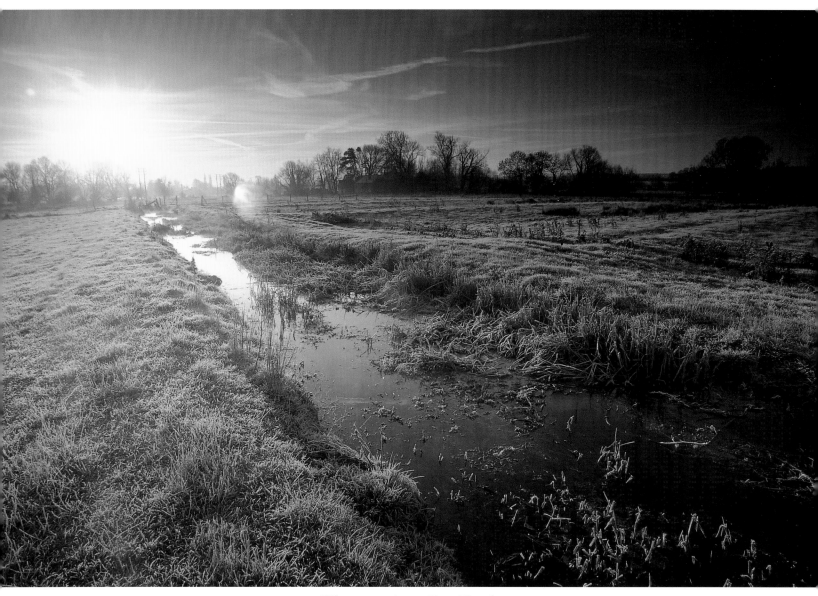

Winter sunrise at East Harnham
Utter tranquillity early on a Sunday morning. The only sound was of frost crunching below one's boots.

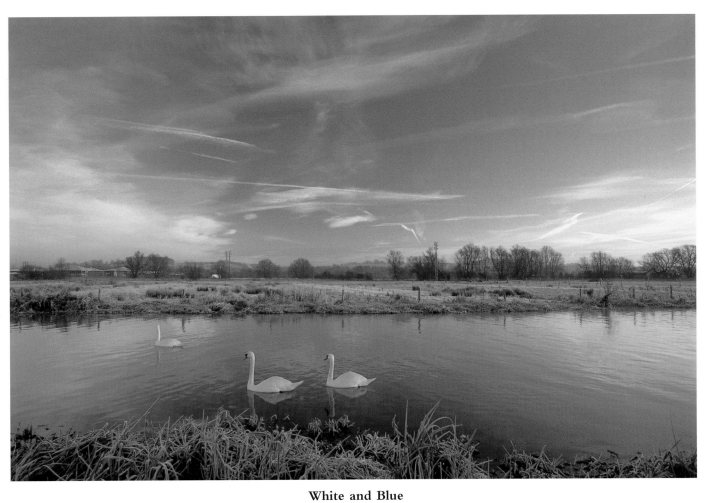

White and Blue
Mute swans drift silently along the River Avon at Salisbury on a cold morning.

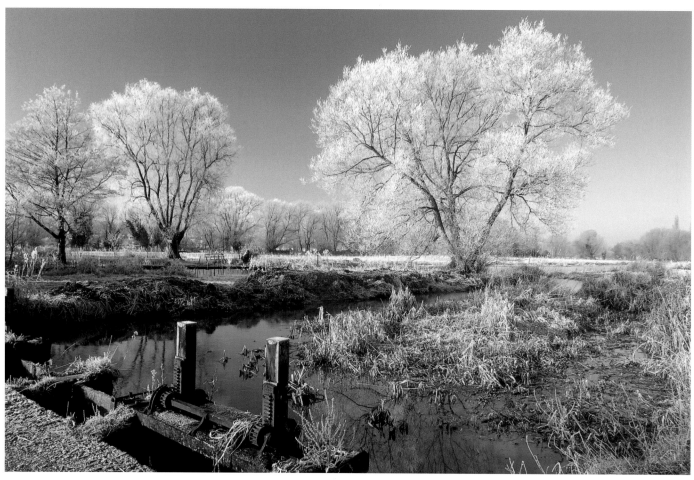

The old sluice gate
The water meadows were created long ago to 'drown' the riverside grass
to protect it from winter frosts and feed it with rich river silt.

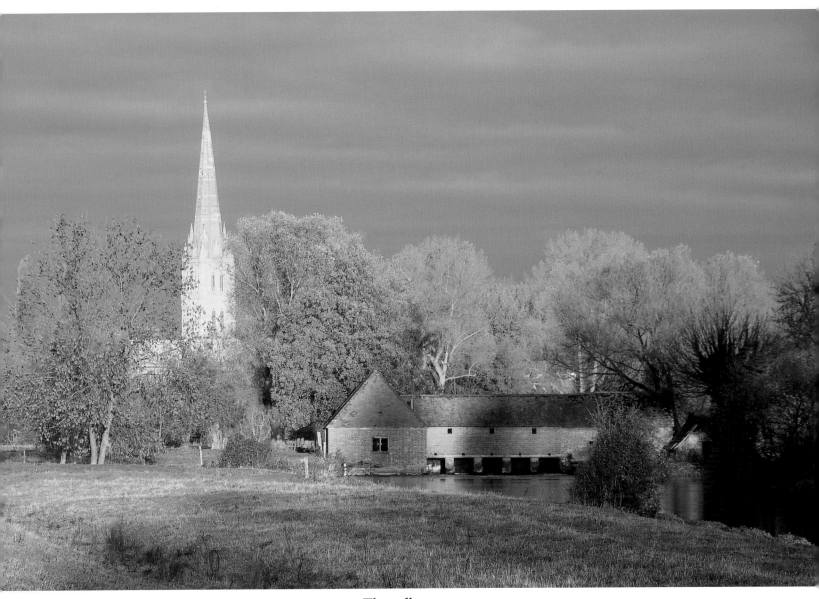

The eelhouse
Autumn light utterly transforms the pale grey stone of the cathedral and lends warmth to the trees and old brick eelhouse.

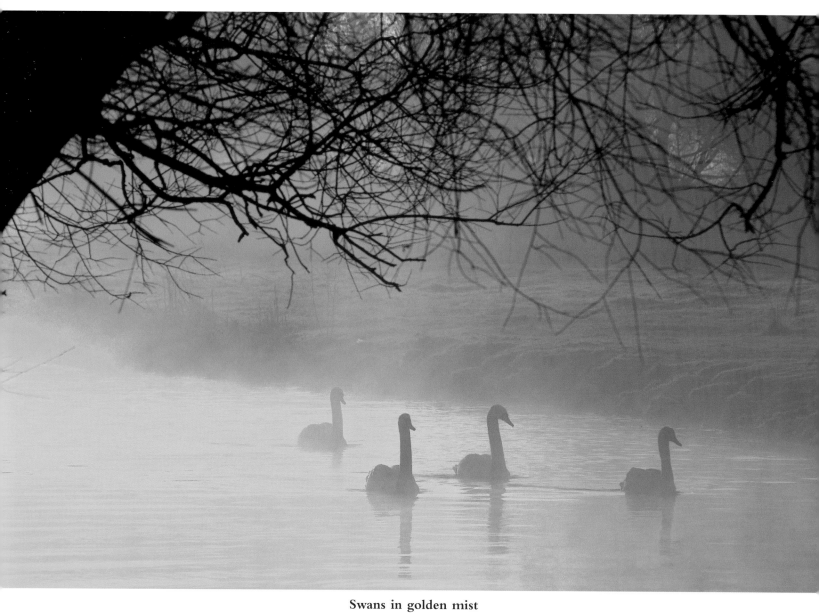

Swans in golden mist
A family group of mute swans drifts through the mist that often blankets the Avon on cold mornings

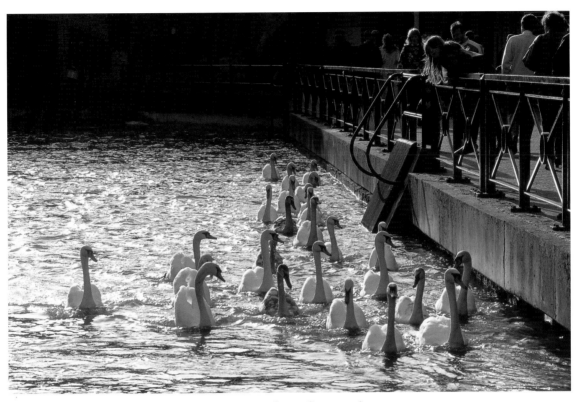

Waiting for a free meal
Backlit swans gather by the Maltings, in the heart of Salisbury,
for warmth and the promise of a free meal.

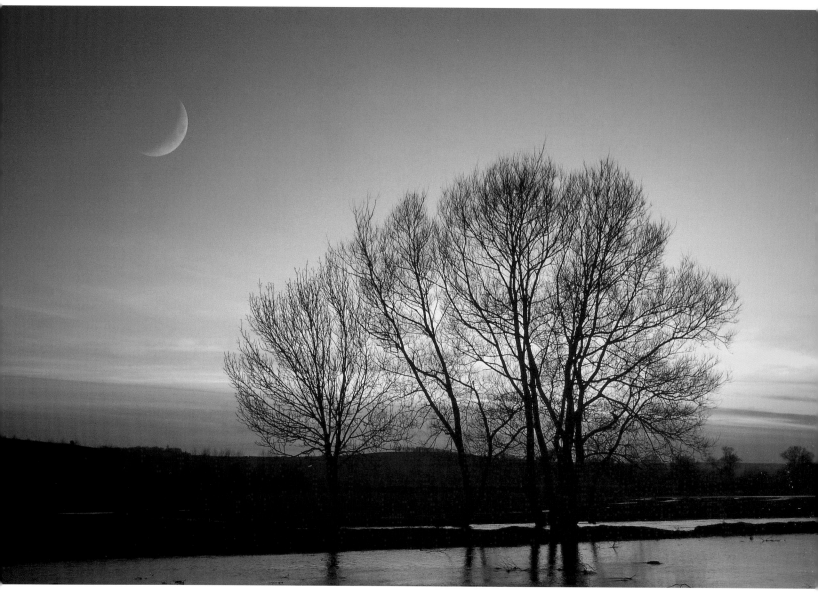

New moon over the Ebble

Once the sun had set, the silver sliver of moon counterbalanced the silhouetted trees and made the scene.

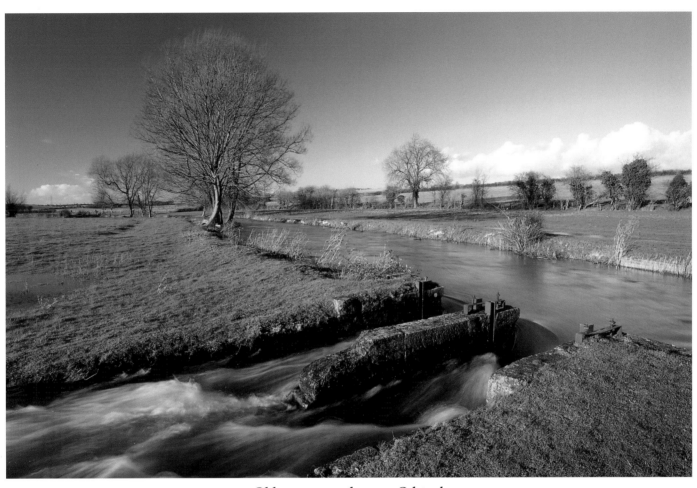

Old water meadows at Odstock

The gentle summer trickle of the Ebble becomes a full-blooded river in winter and spills out onto the meadows.

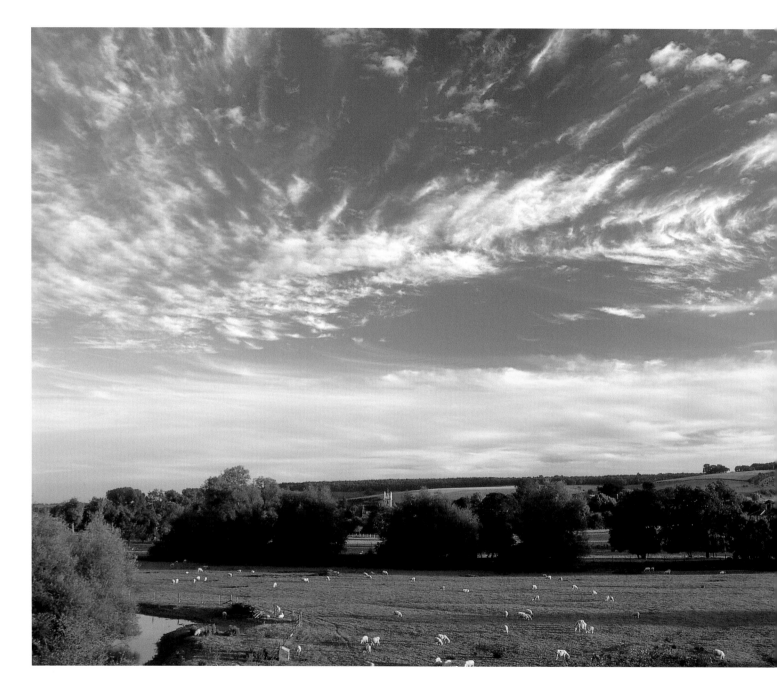

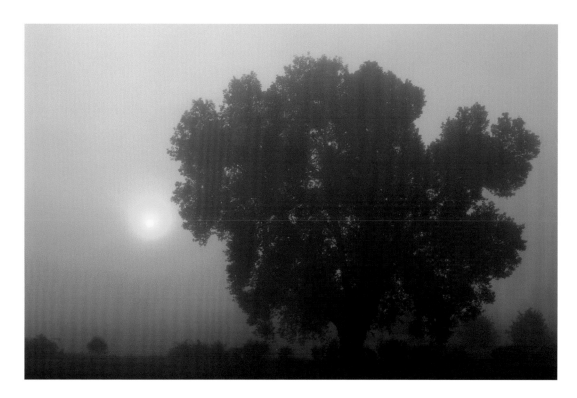

Above
Veteran poplar in fog
These huge, elegant trees are dotted along Wiltshire's riverbanks
and in ancient hedgerows of the floodplains.

Left
Wylye Valley water meadows
Sheep graze lush riverside pastures and the tower of Great Wishford church peeps above the trees.

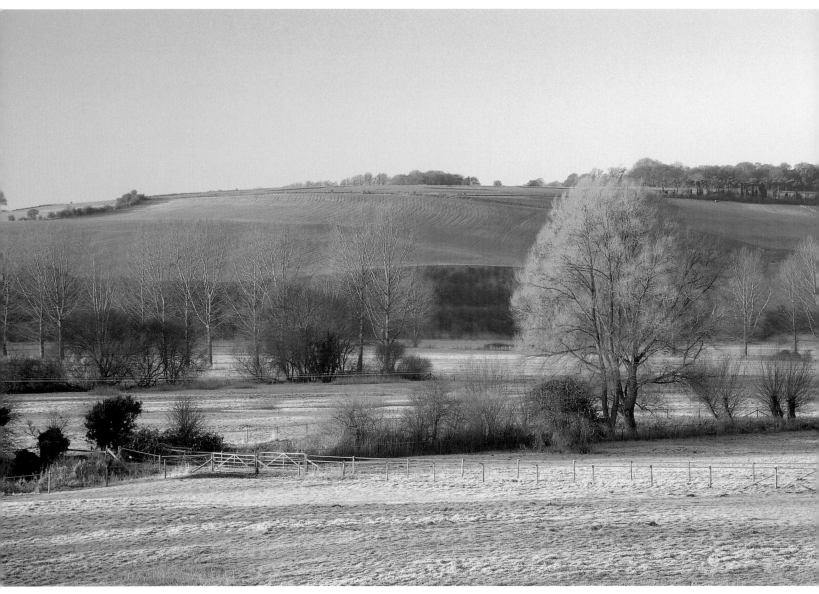

A splash of colour
The vibrant orange of young willow twigs adds cheer to the Wylye valley in winter.
Large numbers of willows of different species hug the riverbanks.

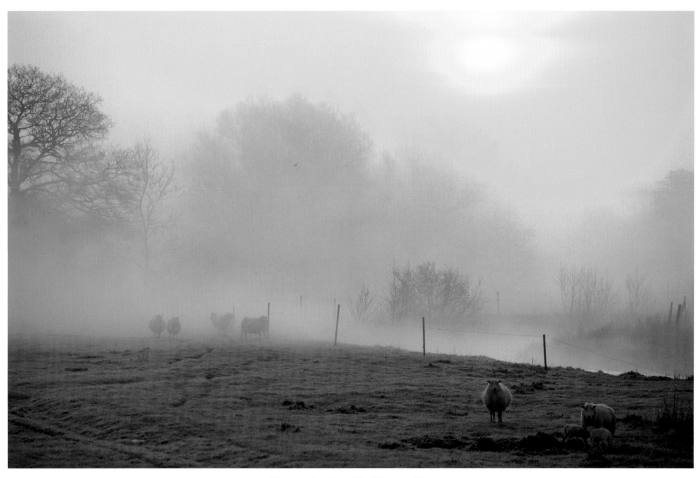

Dawn in the Nadder valley
First light brings warmth as river mist floats eerily next to sheep grazing at Burcombe.

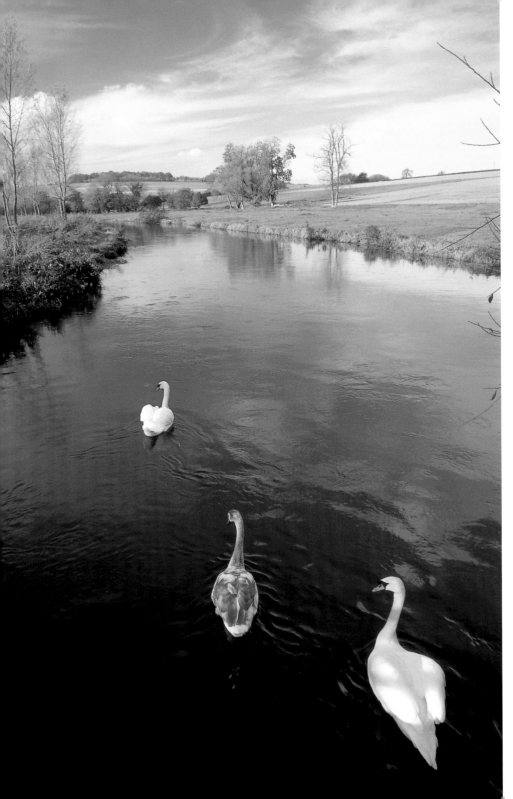

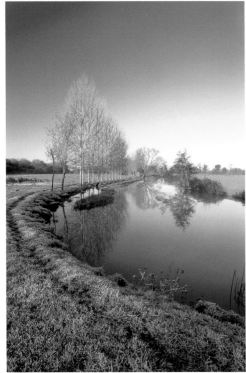

Above
A still winter morning
The early morning sun catches these riverside poplars and will soon melt the frost adorning the banks of the Bristol Avon at Little Somerford.

Left
Swans cruising the Woodford valley
The Avon flows through this attractive valley north of Salisbury, and is one of Britain's cleanest and most important river systems, rich in wildlife.

The crystal-clear Bye Brook
This wonderfully unpolluted stream,
alive with damsel flies above and
darting trout within, flows through
the Cotswolds-like north west of
the county.

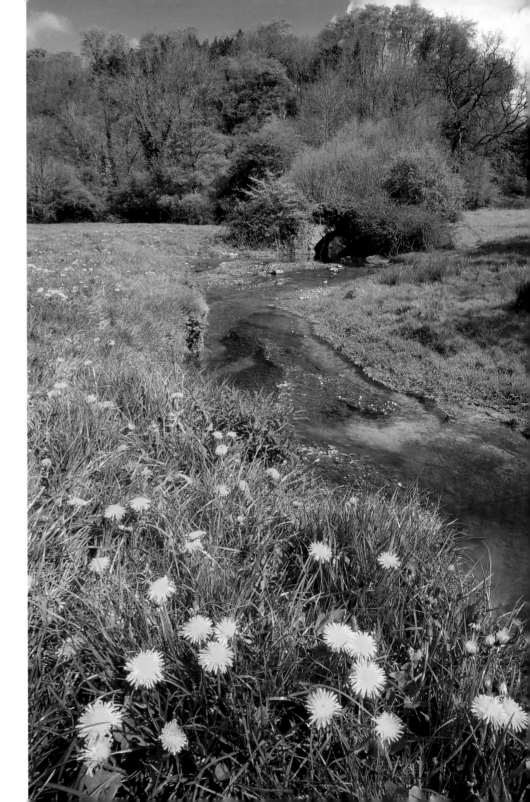

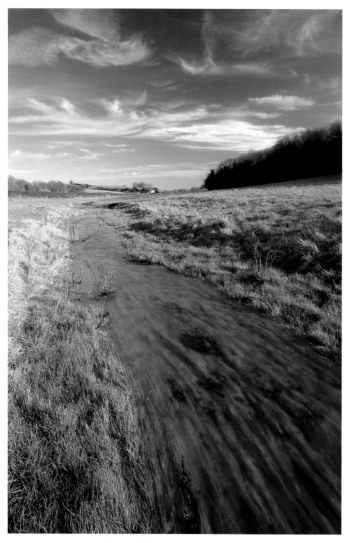

The Ebble in early spring
This cold, crystal-clear chalk stream rushes
past Fifield Bavant. The secretive otter is returning
to many of Wiltshire's streams and rivers.

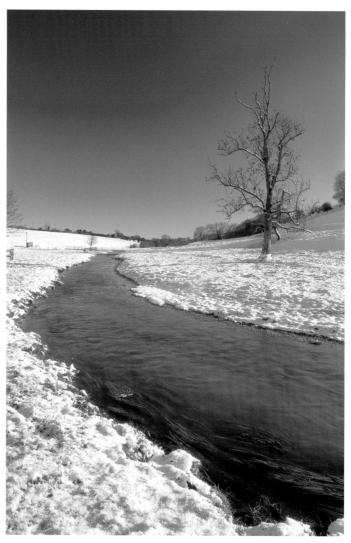

The Ebble in winter
Snow even reaches the sheltered chalk stream
valleys, but life is less harsh than up on the
exposed, windswept tops of the downs.

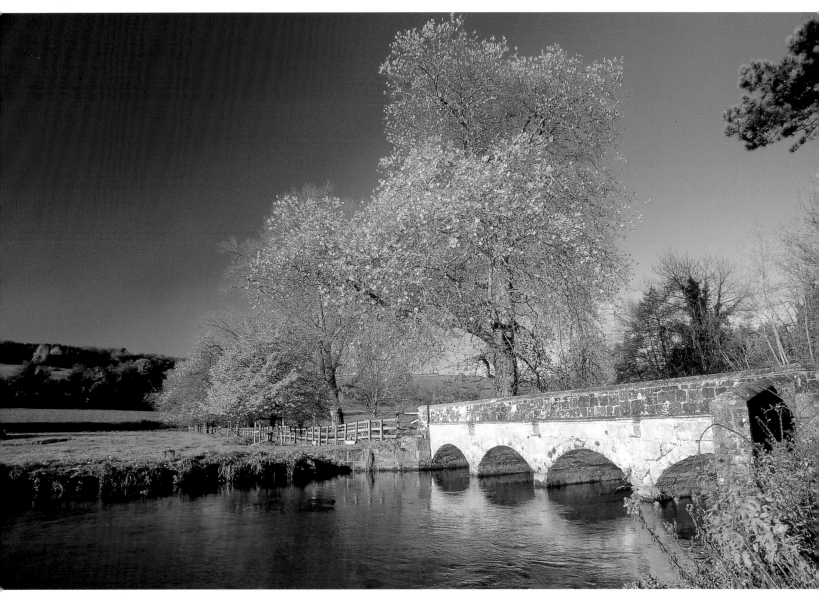

Bridge over the Avon
Your eye is led across the pretty bridge at Little Durnford Manor and up to the striking orange tree on the horizon.

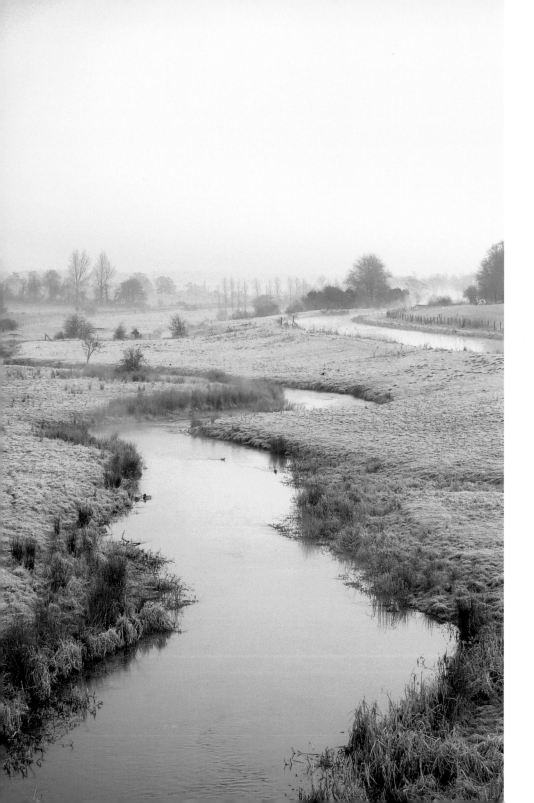

In the bleak mid winter
The River Dun and the Kennet and Avon Canal lie side by side near Great Bedwyn, reflecting the first pink flush of dawn, on a bitter January morning.

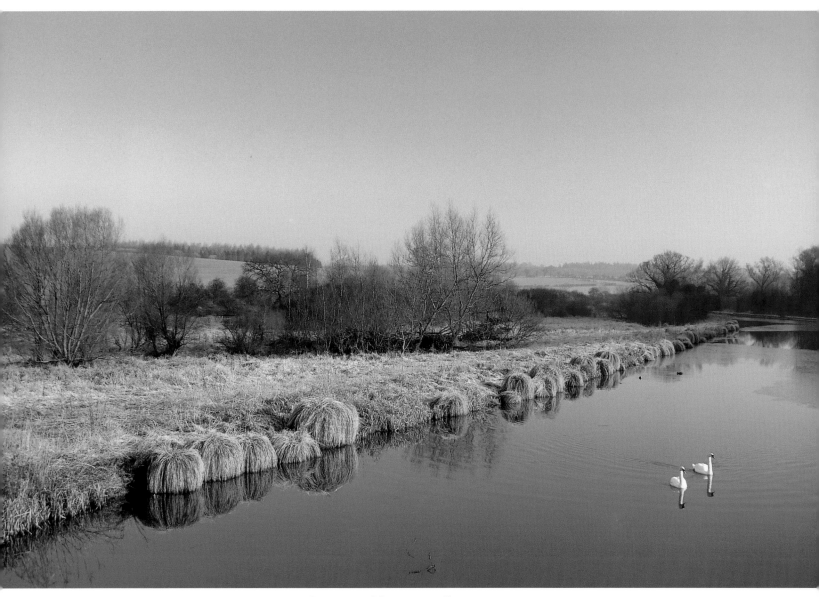

Swans cruising tranquil waters
The Kennet and Avon Canal is very quiet during the winter months. Running from Bristol to
Reading, its Wiltshire stretch sits languorously in Pewsey Vale, cutting the county in two.

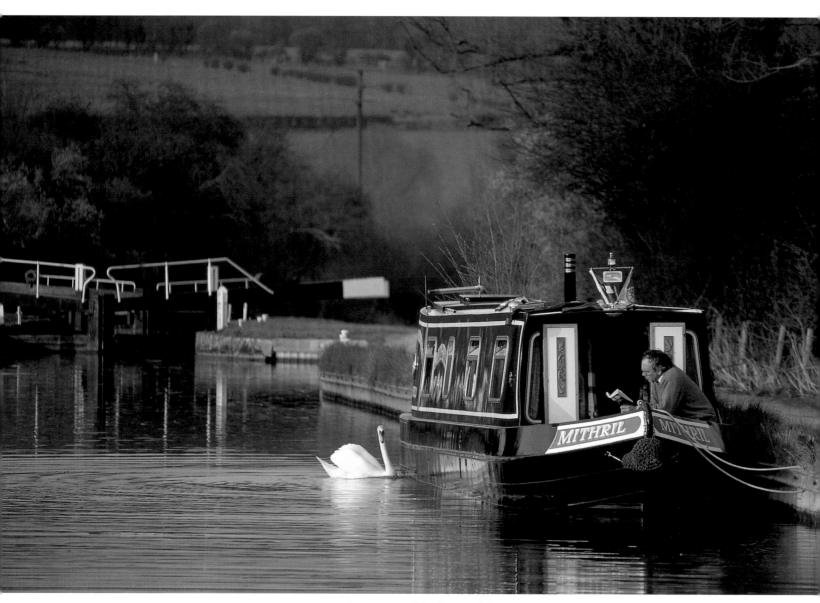

At peace with the world

Boating on the canal lets you escape from the hustle and bustle of modern life.
Narrow boats potter and so do the people on them.

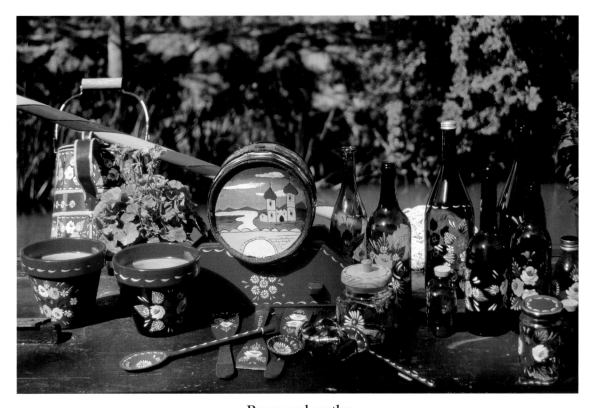

Roses and castles
Artistic people living on narrow boats still make and sell
traditional canal ware, seen here at Pewsey Wharf.

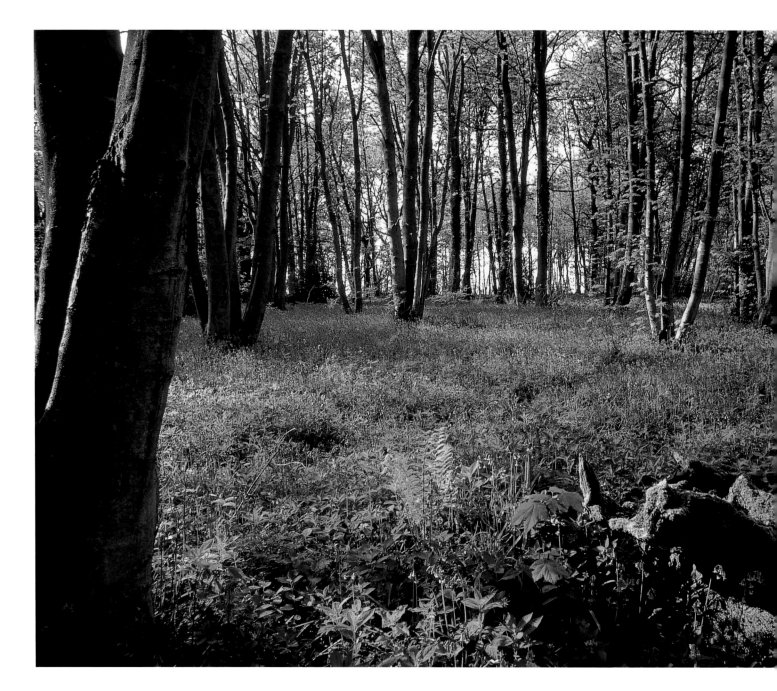

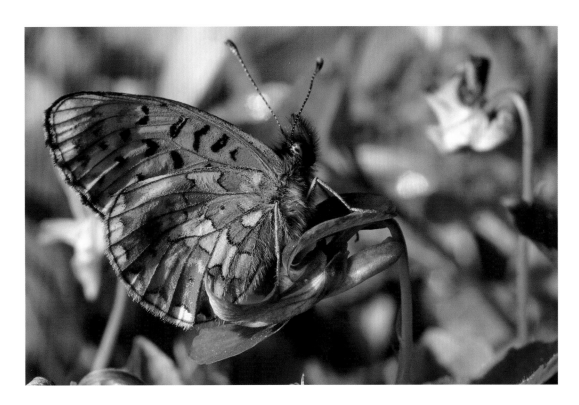

Above
Pearl-bordered Fritillary
The southern woods are home to clouds of butterflies. This rare and exquisite
little butterfly is reliant on violets and the traditional practice of coppicing hazel.

Left
If you go down to Grovely Woods...
Morning light strikes an ancient woodland floor, thickly carpeted with bluebells and ferns.

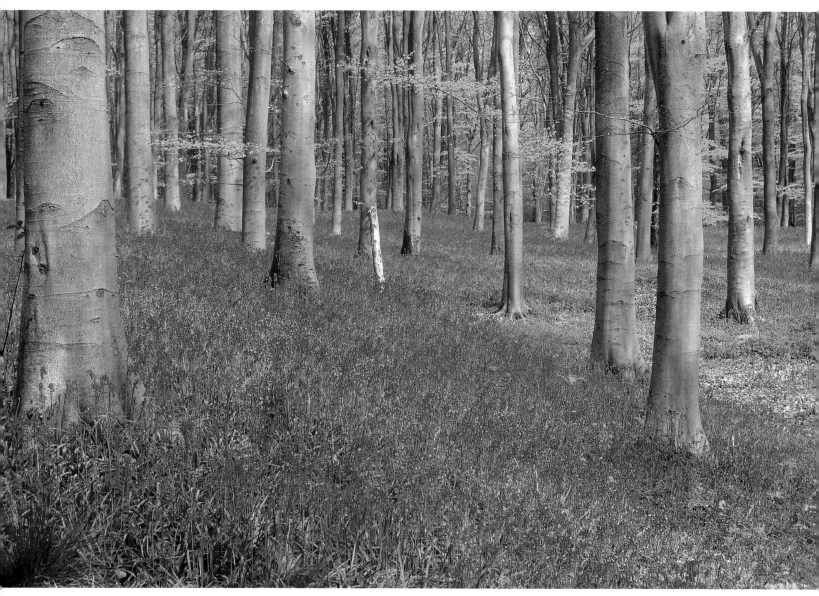

Rhapsody in blue

West Woods, near Marlborough, becomes an almost unbroken swathe of
quintessentially English bluebells in spring, and the air is heavy with their sweet scent.

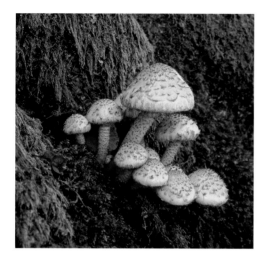

Above
Magic mushrooms
These Shaggy Pholiota, sounding more like a rap artist than fungi, were among the many varied species found during a brilliant autumn fungal foray in the ancient woodland of Savernake Forest.

Right
Veterans of the forest
Savernake was once a much larger hunting forest, but even today you can still find ancient trees. These beautiful beech pollards stand in the delightfully-named Red Vein Bottom.

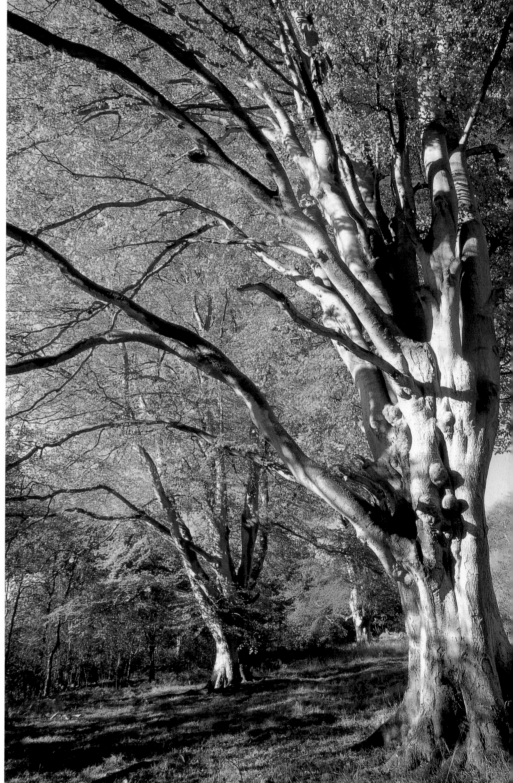

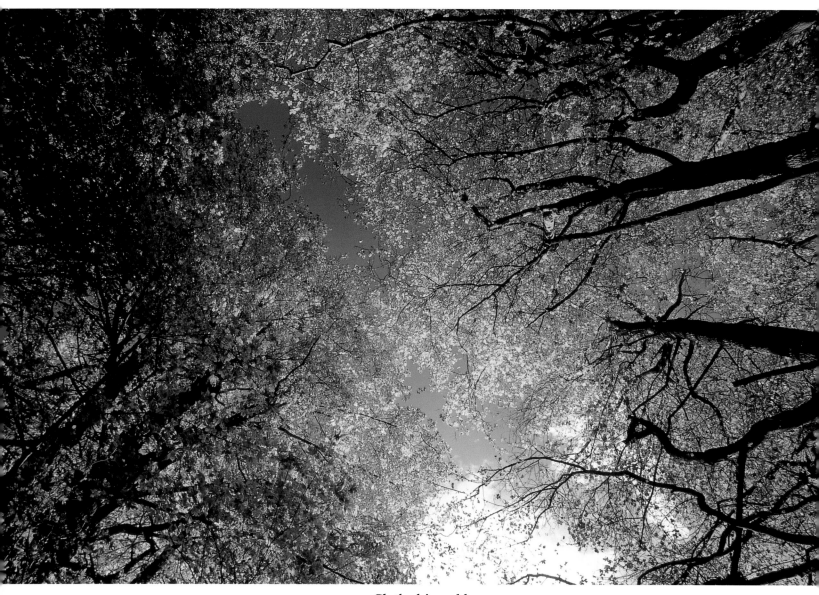

Clothed in gold
A woodmouse's view of the vibrant autumn colours of field maples in Green Lane Wood.

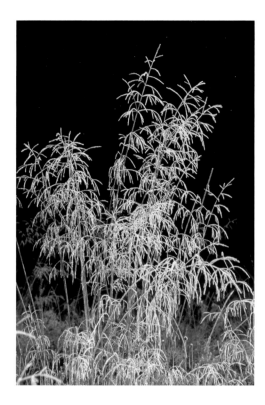

Above
Backlit grasses
Grass clumps had been turned into
sparkling works of art but, by the time
most people are up and about, the
delicate spectacle will have vanished.

Right
A woodland glade
A sharp hoar frost had transformed
Bentley Wood overnight. A neighbour
rang, after walking her dog, to say
'Get over the wood right now!' and
it was, indeed, quite stunning.

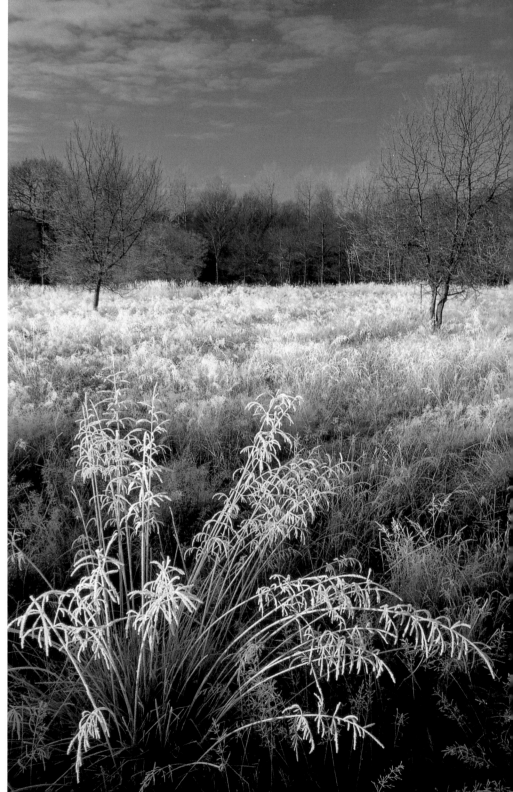

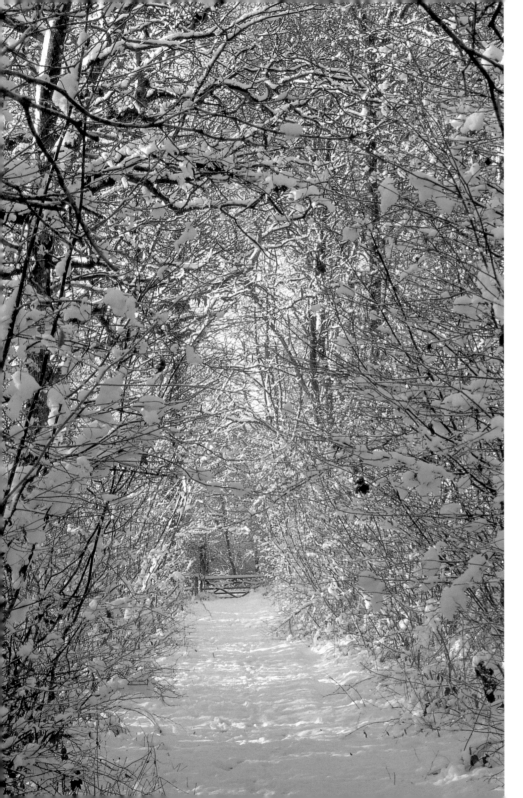

Silent world of snow
Snow had fallen and a morning walk
in Blackmoor Copse was conducted
in appreciative silence. The deer were
hunkered down, no birds sang, no
sound even of our own footfalls.

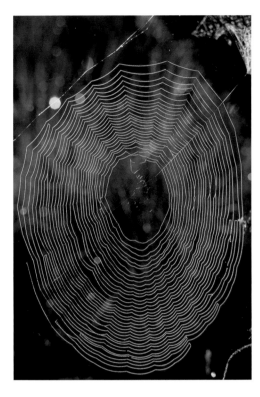

Above
Hanging by a thread
A spider's web looking as if it was spun from gold - so deceptively delicate and so intricate, and yet so strong and deadly.

Right
Landford Bog at dawn
A heavy morning dew picks out myriad spiders' webs at Wiltshire's only heathland bog, at the edge of the New Forest.

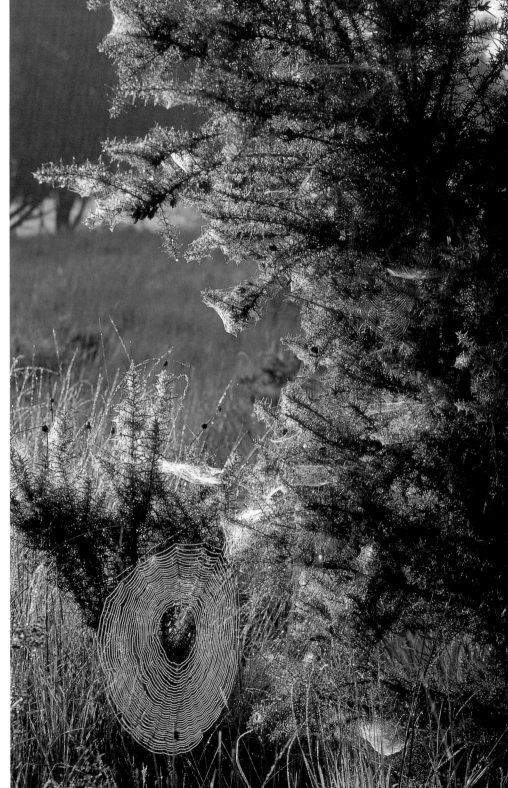

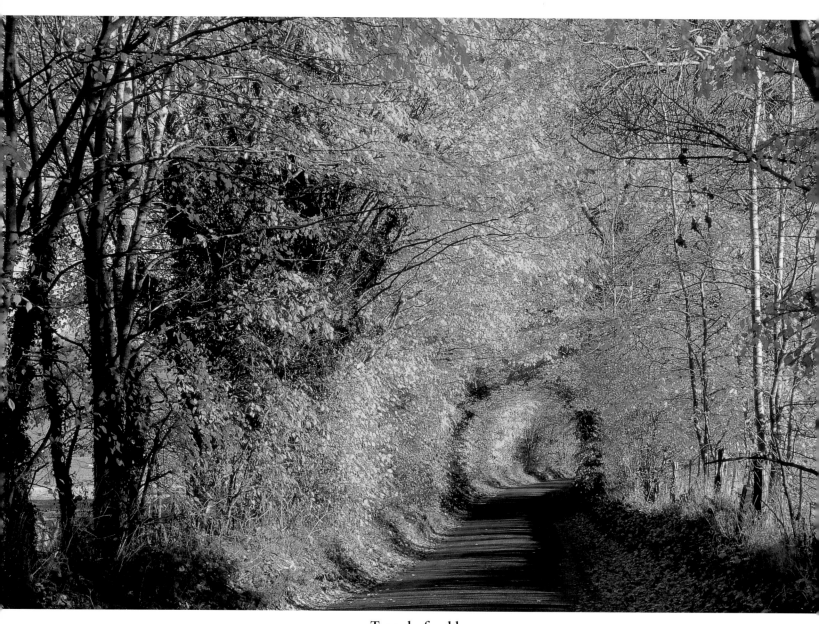

Tunnel of gold
This quiet country road near Berwick Saint John is part of some 4000 miles
of trackways, footpaths and green lanes still found in the county.

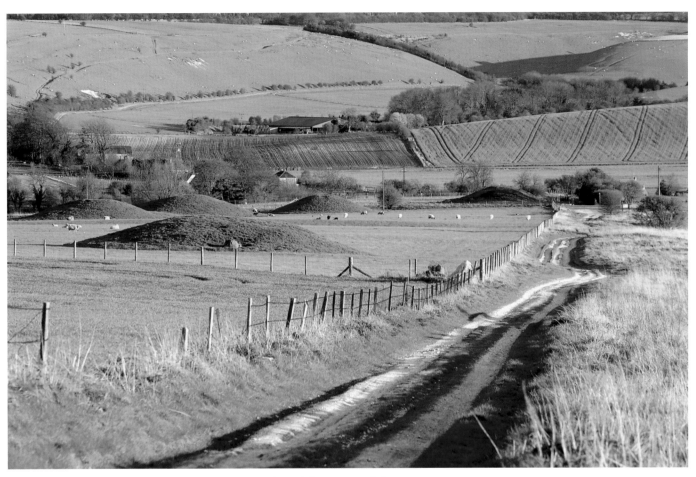

The Ridgeway and barrows.
This prehistoric highway crosses Avebury Down, passing a cluster of burial mounds.
Bell, bowl, disc, long, pond and saucer barrows are as much a feature of the landscape as the sheep.

Scots Pine Clump
Clumps of trees were planted to
mark the route of tracks and ox droves
– the ridgeways – which ran across
the tops of the downs.

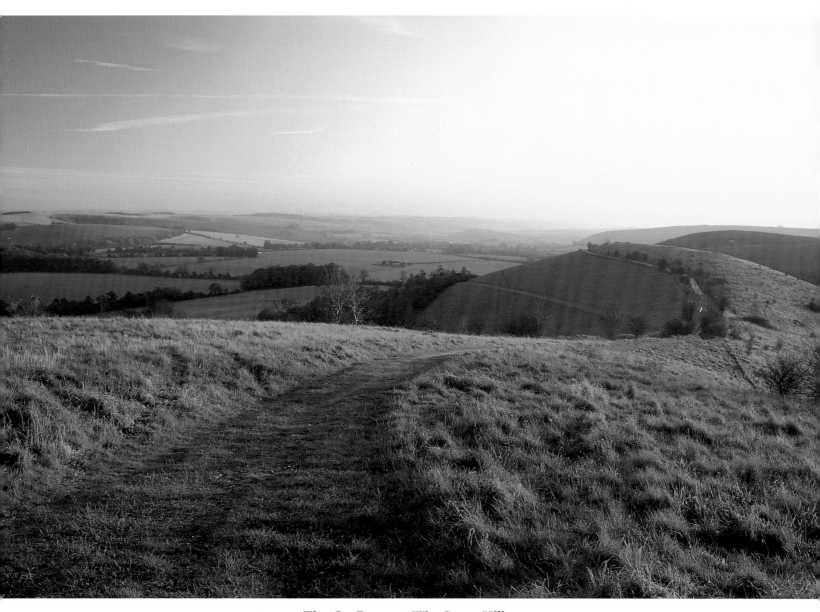

The Ox Drove at Win Green Hill
Once used for driving cattle to London from the south west, this ancient track gives stunning
views of Cranborne Chase and the Ebble Valley as it follows the ridge of the downs.

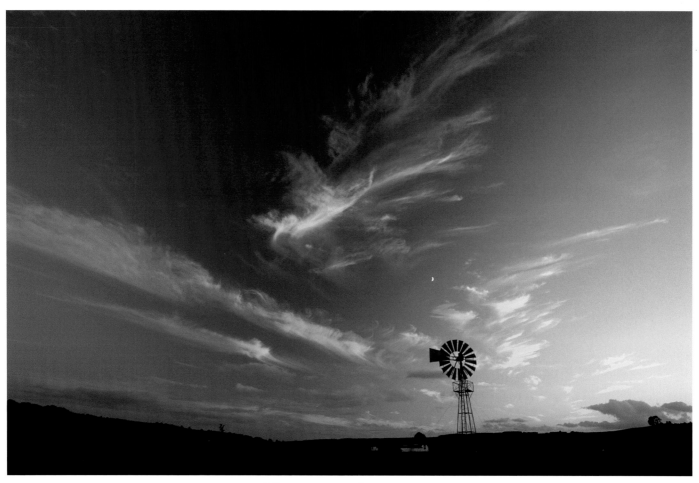

Waterpump and new moon
A Roman road joins the old Clarendon Way close to this familiar landmark near the village of Pitton.

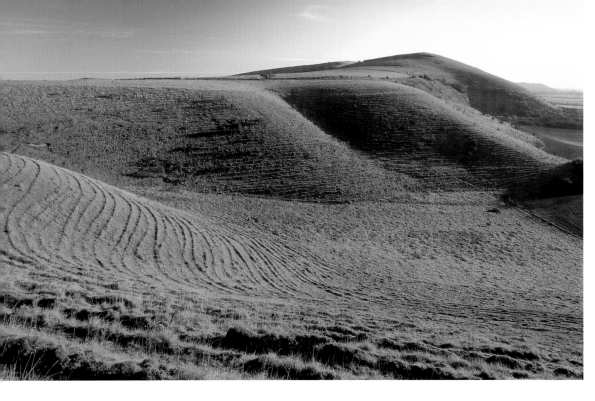

**Pewsey Downs
at daybreak...**
The terracettes, so
characteristic of downland,
are most probably the
result of natural erosion of
topsoil on steep slopes.

**...And on a clear
winter's day**
Pewsey Downs National
Nature Reserve is a walker's
paradise where you can lose
yourself in a unique, ancient
landscape. Sharp morning
sunlight lends a curiously
metallic quality to the
frost-coated hills.

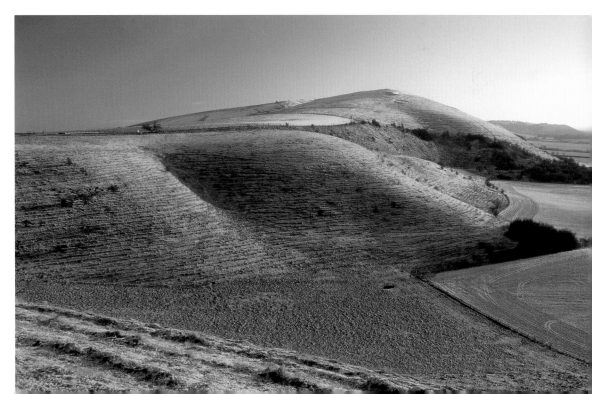

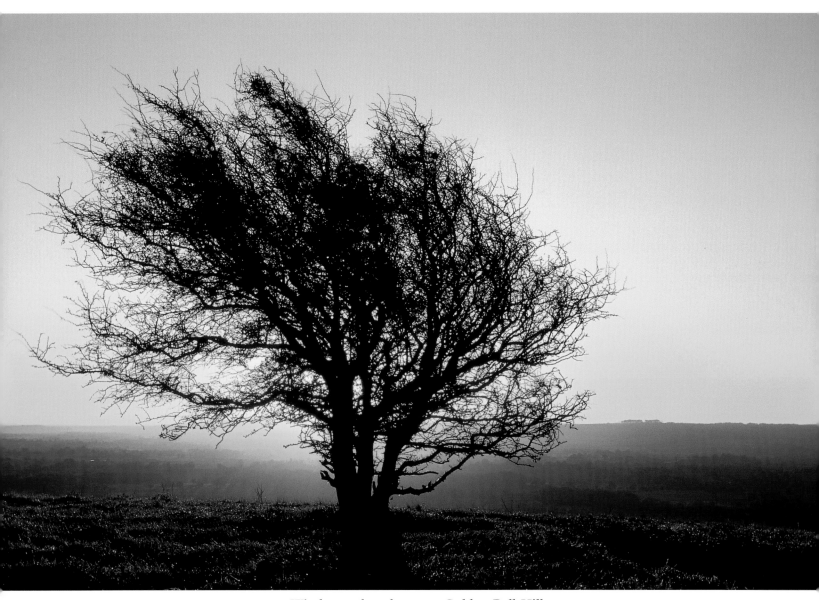

Windswept hawthorn on Golden Ball Hill
The tree is silhouetted as the low light just catches the morning dew and makes it sparkle.

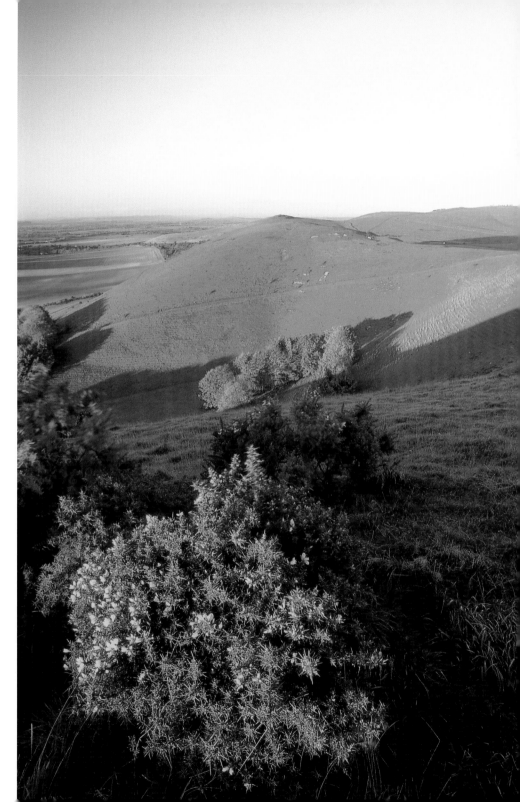

Knap Hill from Golden Ball Hill
Dawn light really brings autumn colours
alive in a landscape perched at the
southernmost edge of the
Marlborough Downs.

113

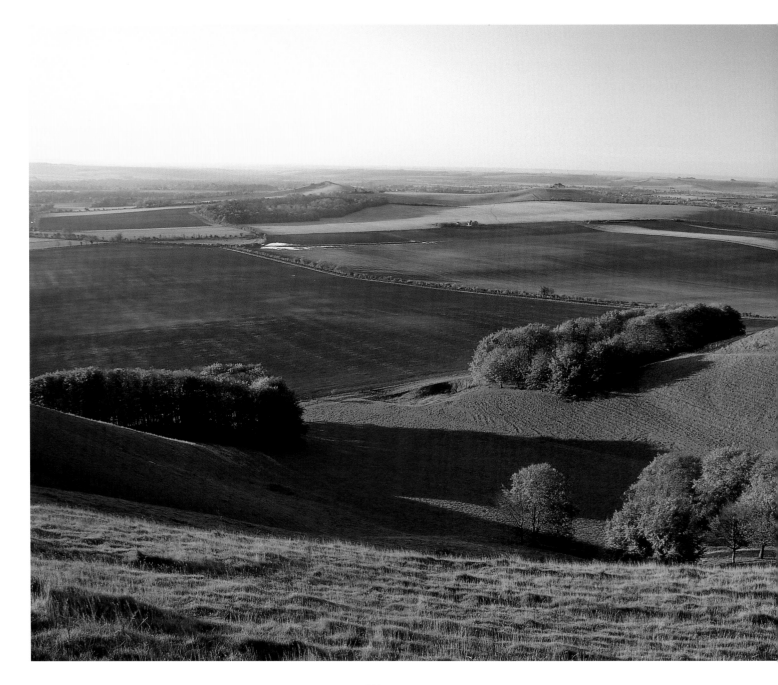

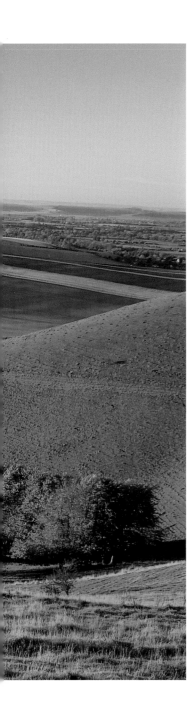

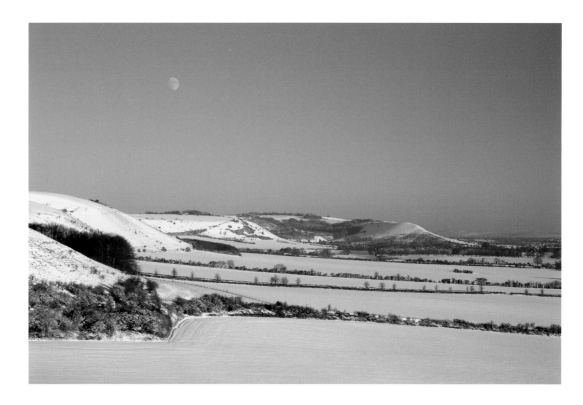

Above

The Giant's Grave

Snow seems to soften the scene, looking towards the Giant's Grave
at the far eastern end of the Pewsey Downs.

Left

Pewsey Vale in the autumn

Ancient trackways crisscross the landscape but very few roads blight the Vale.

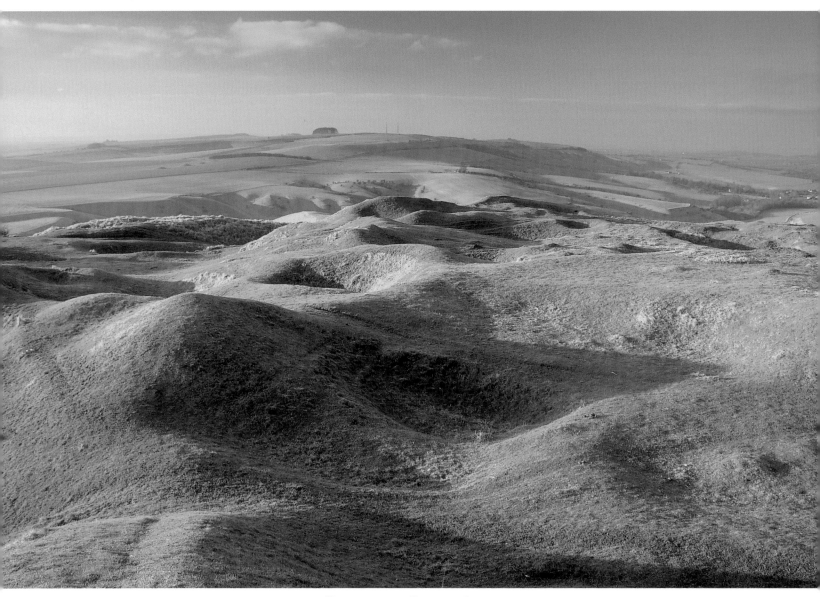

No traffic, no power lines, no houses
Oldbury Castle, on Cherhill Down, has stupendous views. The hillfort
is pitted with flint diggings, accentuated by the low dawn light.

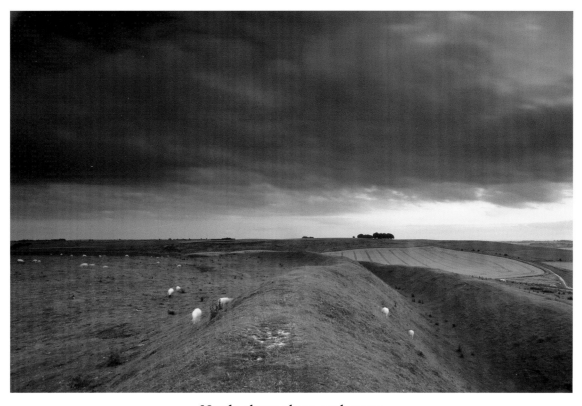

Newly shorn sheep and storm
The lowering sky over Barbury Castle hillfort emphasizes the
bright white of the grazing ewes with their lambs.

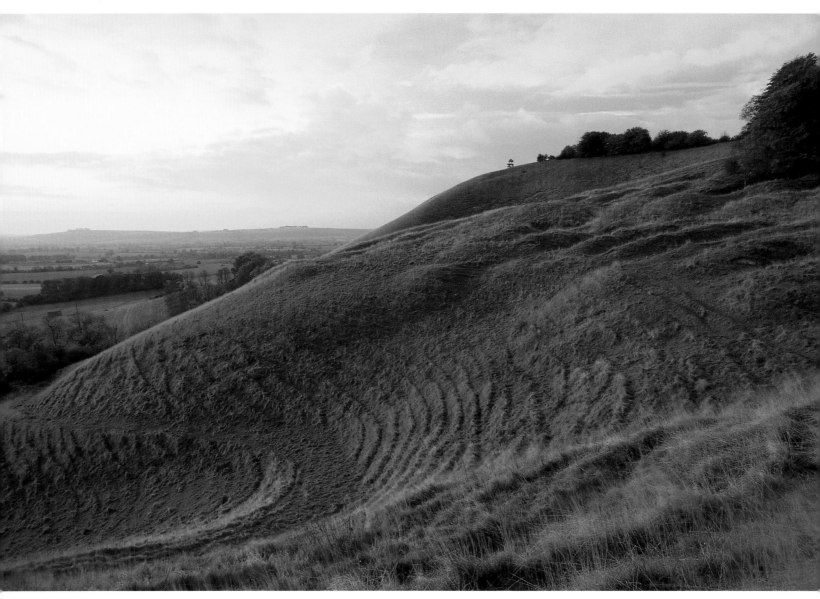

Pewsey Vale from Martinsell Hill
Of all the fine hills in Wiltshire, Martinsell is probably the best.
Rising to nearly 1000 feet, it has staggeringly beautiful views of the Vale.

Battered old beech
This gnarled and twisted pollarded
tree has provided shelter to generations
of sheep on windswept Martinsell Hill for
maybe two hundred years or more.

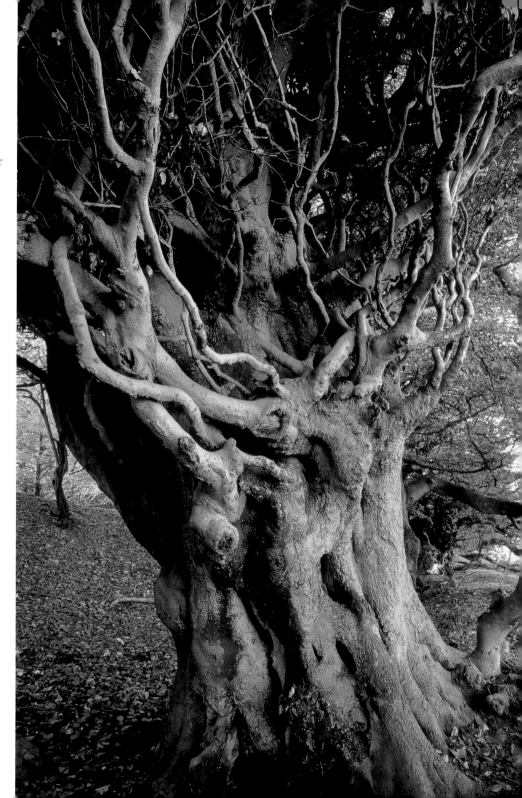

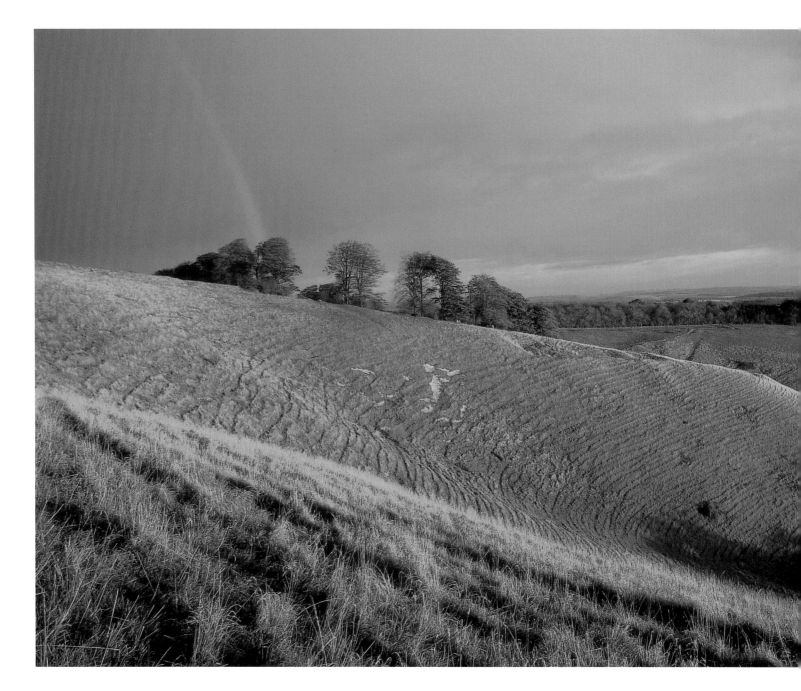

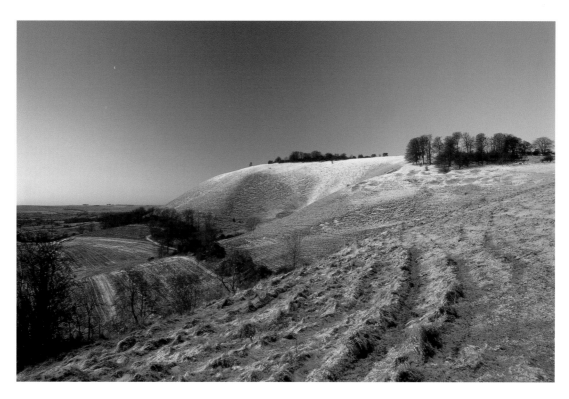

Above
A sprinkling of icing sugar
The stock tracks, with their light dusting of snow, lead your eye up to the
summit and hence to the new moon. It's worth the steep climb up Martinsell
for the exhilarating sense of solitude and timelessness at daybreak.

Left
Rainbow over Martinsell
Dawn light came at the end of a terrific storm and lit this autumn scene.

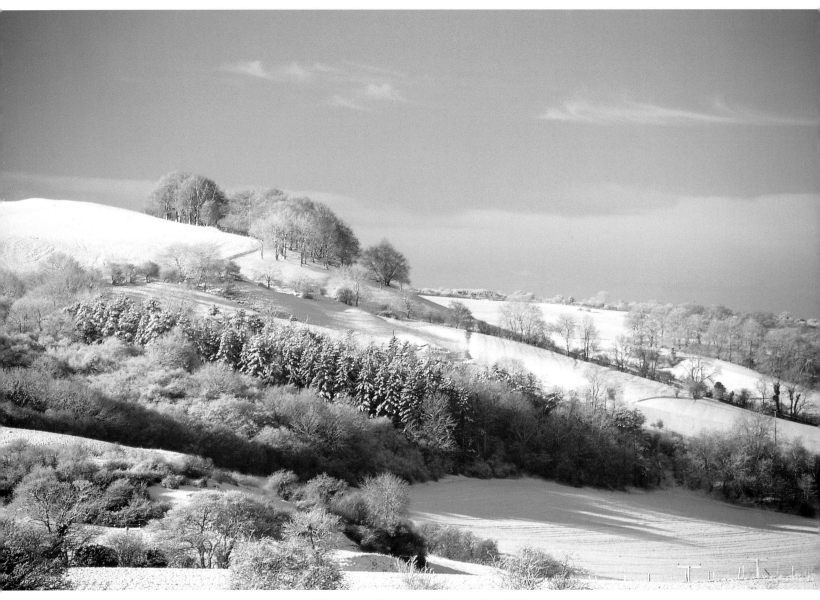

Winter landscape at King's Play Hill
Soft light makes a painterly scene and your eye, quickly drawn up to the
top of the hill, then drifts down across the rest of the scenery.

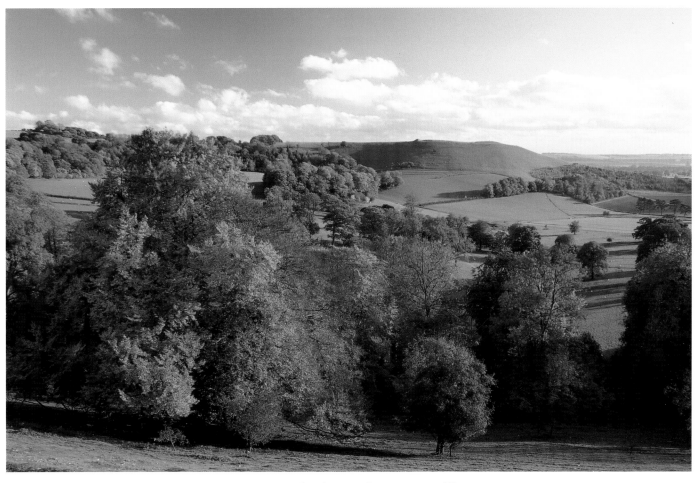

Autumn landscape from Oare Hill
The fine grounds of Rainscombe House nestle within the horseshoe formed by Oare Hill
and the Giant's Grave atop the western promontory of Martinsell Hill.

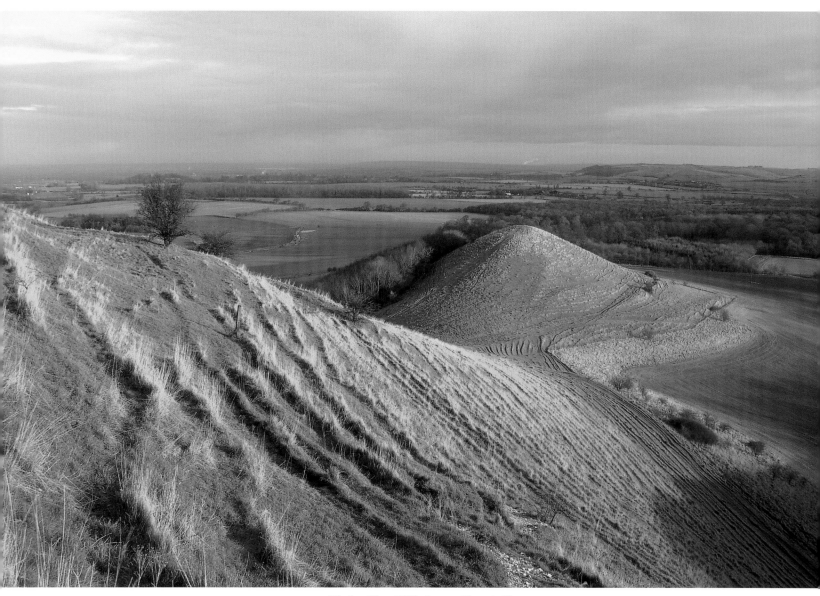

Little Cley Hill from Cley Hill

High on this chalk knoll, amidst ancient burial barrows, there are 360 degree views of the flatlands hereabouts.

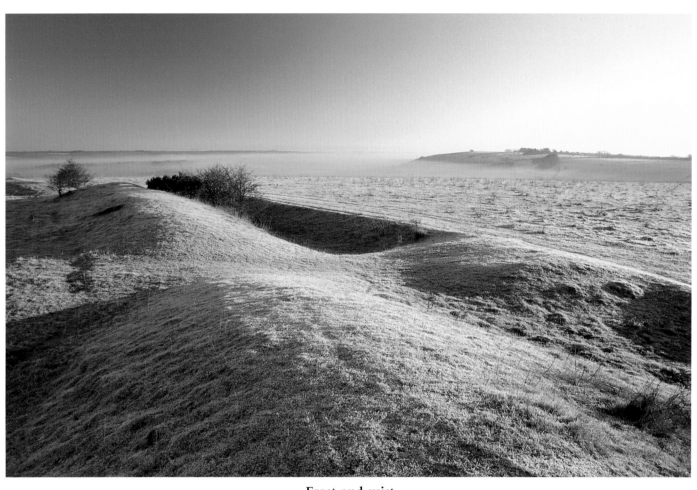

Frost and mist
Chiselbury Hillfort on Fovant Down stands above the mist filling the valley, until the sun burns it off.

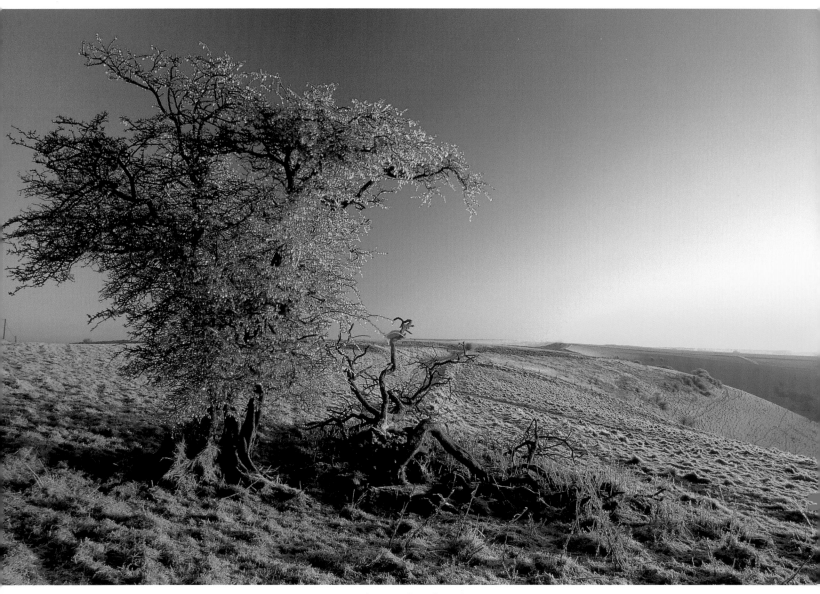

Hawthorn after freezing rain
This stunted, wind-ravaged tree at Quarry Bottom was laden with ice,
which absolutely sparkled as the bitterly cold day dawned.

Umbellifer in ice
A brief magical moment, soon after
daybreak, when everything was sealed
in sparkling ice after freezing rain.

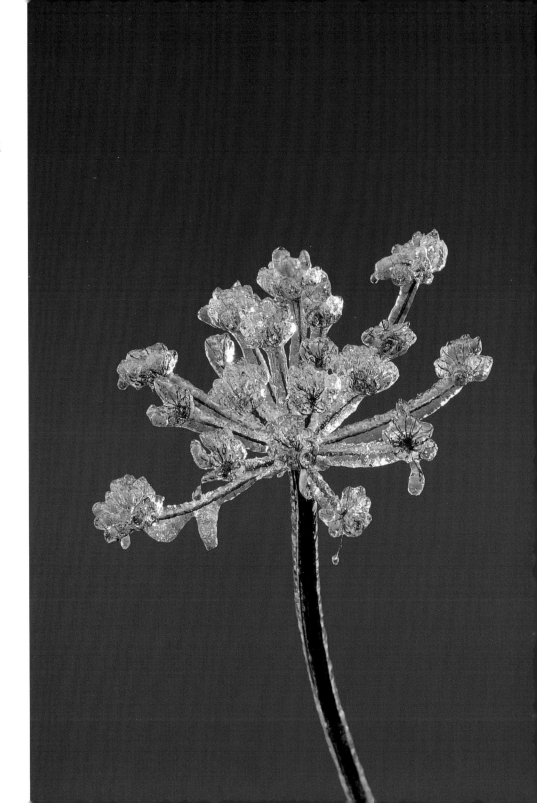

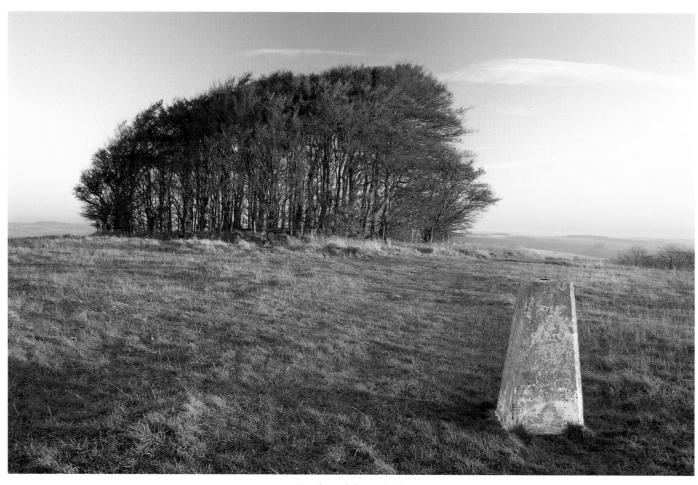

Sculpted by wind
This fine beech clump atop Win Green Hill has been buffeted and shaped by the prevailing winds.

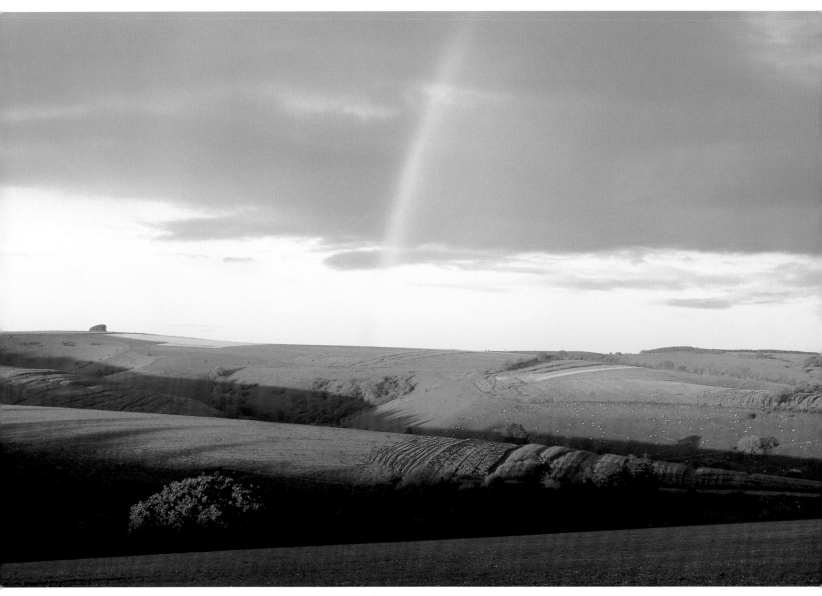

Beech clump and rainbow
The beeches on Win Green Hill are now dwarfed by the dramatic landscape of Cranborne Chase.

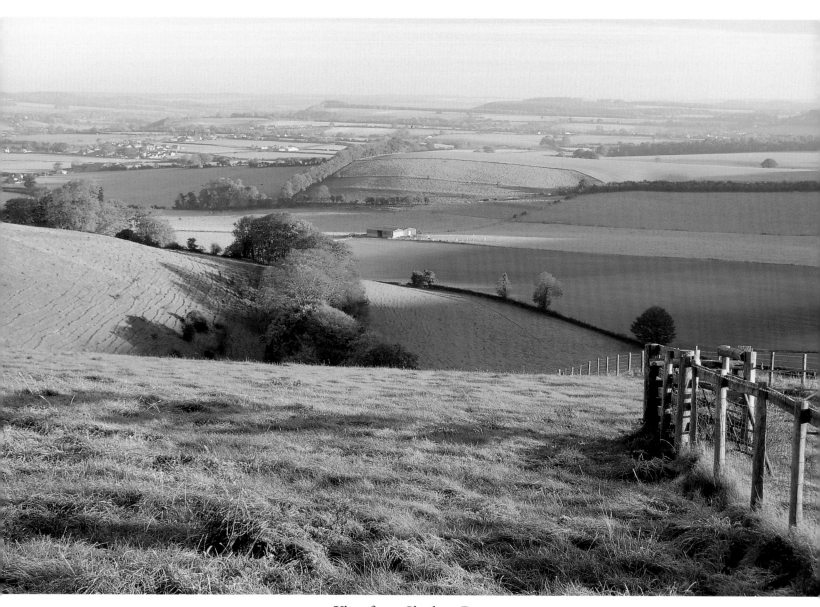

View from Charlton Down
The last downland before Dorset has panoramic views of the beautiful Donheads and the Vale of Wardour.

Wild carrot at Coombe Bissett Down

Two thirds of Wiltshire lie on chalk and there is more beautiful, flower-rich, unimproved downland than anywhere else in England.

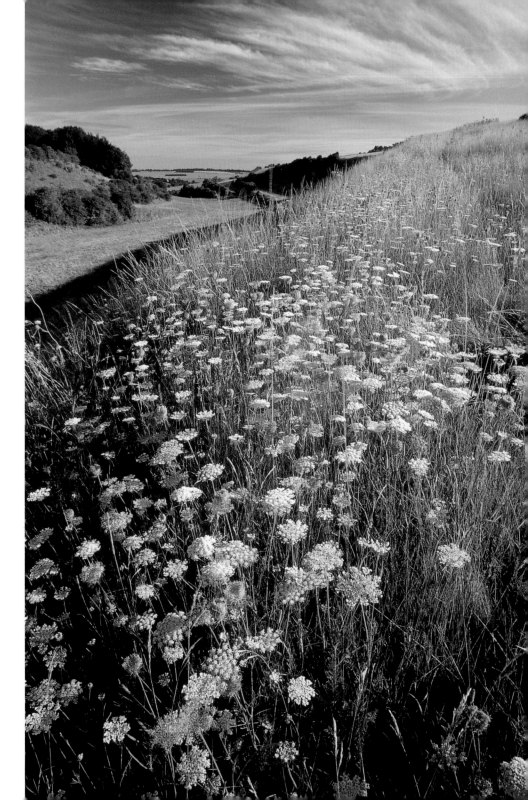

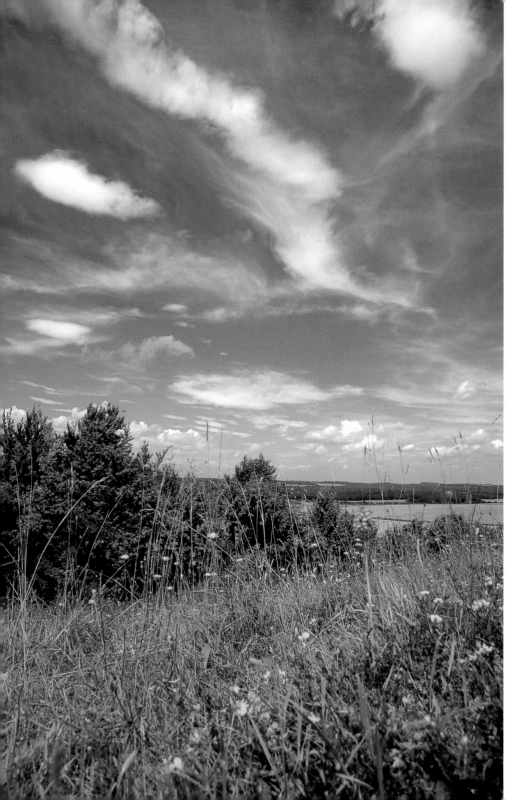

**Pyramidal orchid
and clouds at Dean Hill**

This Barbara Cartland of orchids
brightens the downs in high summer.

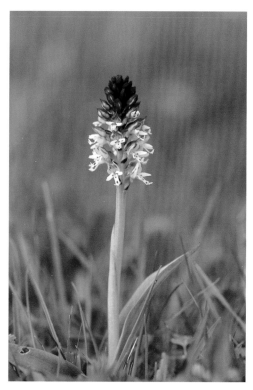

Above:

The diminutive burnt orchid

This rare, dainty orchid is found on downland in the south of the county. As yet, nobody knows why hundreds or even thousands flower on a site in some years but few or none in others.

Right:

Storm over Clearbury Ring

The dark, threatening sky and low view point really makes the green-winged orchid and cowslips stand out.

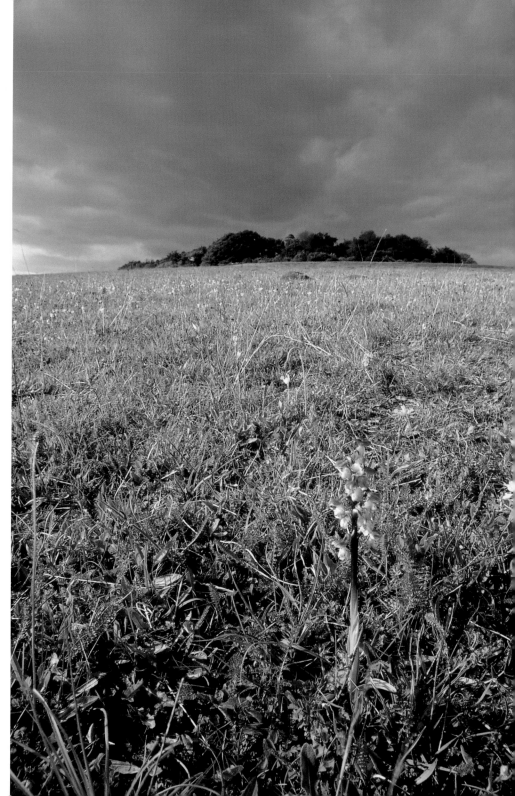

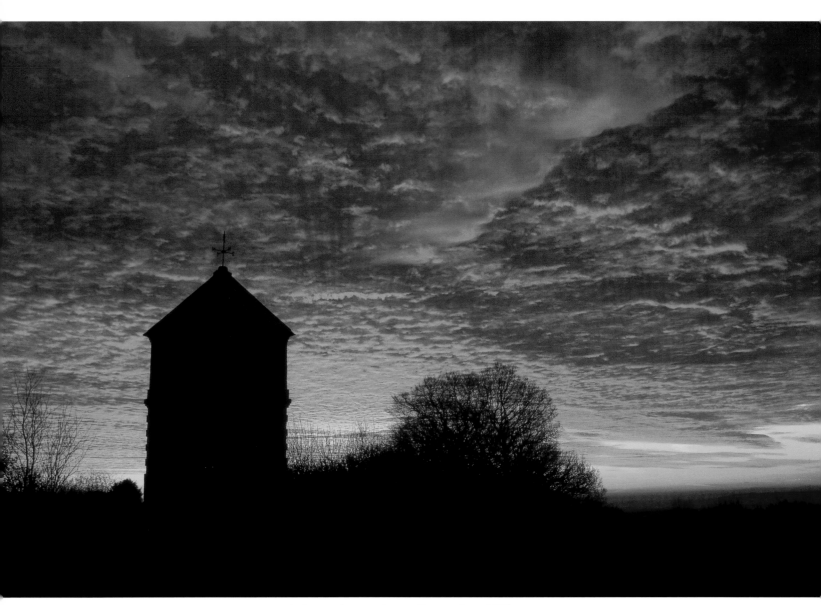

A fantastic sunrise at Pepperbox Hill
Octagonal Eyre's Folly, known as The Pepperbox, sits on fine chalk downland
with views to the south coast as well as to the spire of Salisbury cathedral.

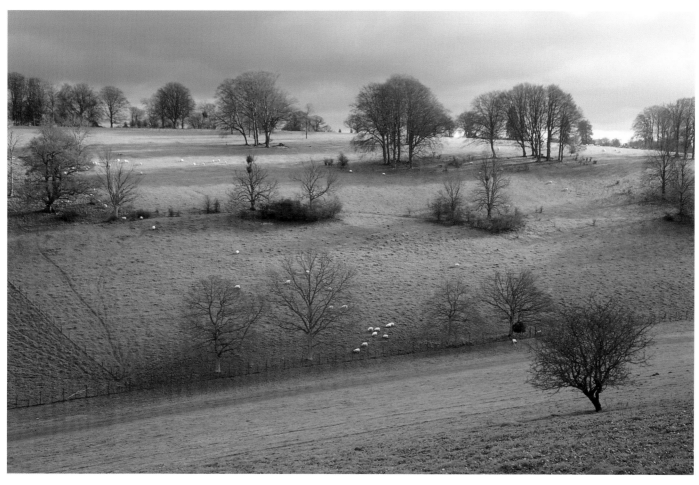

Sheep grazing on Tinkley Down
Bleating sheep graze this gentle coombe at Tollard Royal.
It could easily be a scene lifted straight from a Thomas Hardy novel.

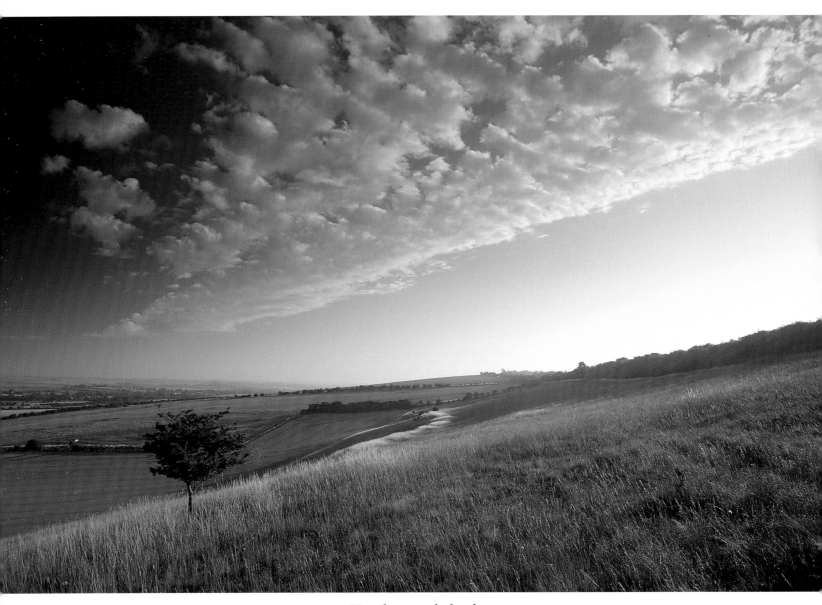

Hawthorn and clouds
The day dawned clear at Cockey Down and the scene lacked impact until, after a long wait of two hours,
some clouds conveniently aligned themselves with the slope and 'made' the picture.

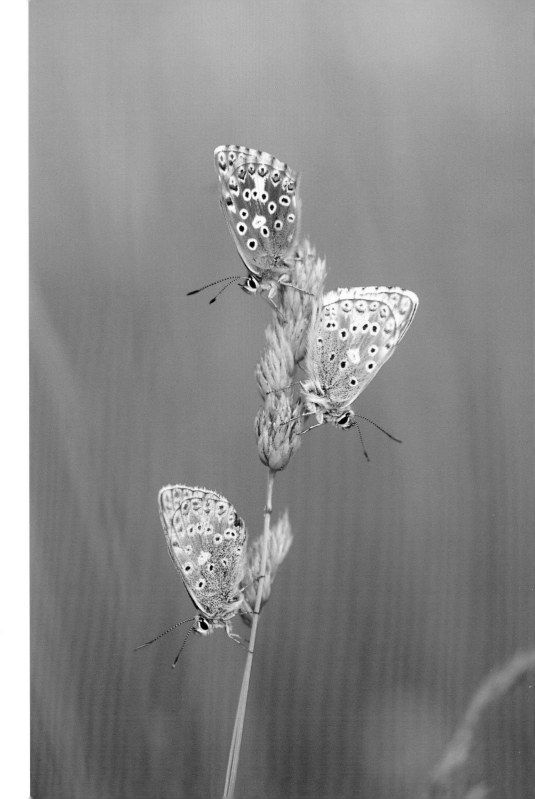

Chalkhill blues roosting at Cockey Down

This female, and two elegant male companions, were 'parked' in their typical head-down position.

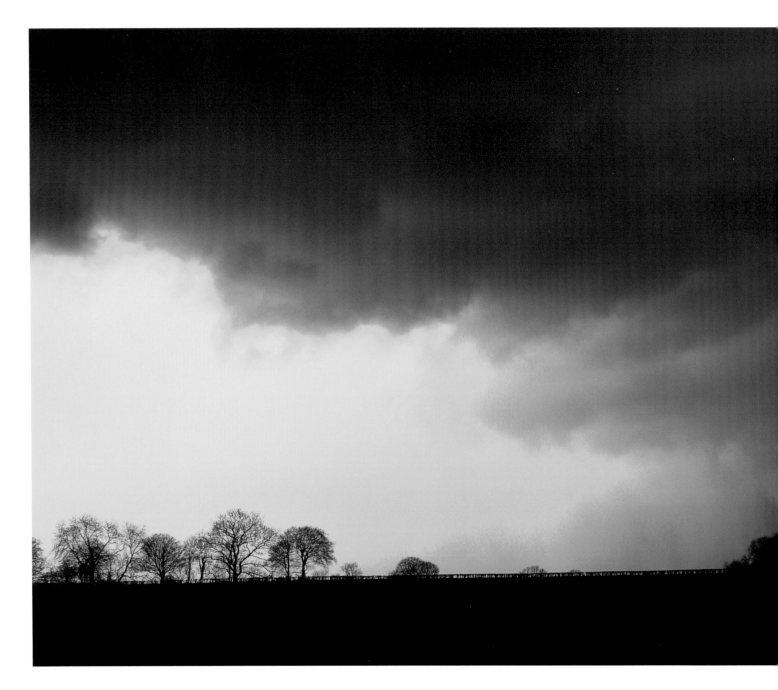

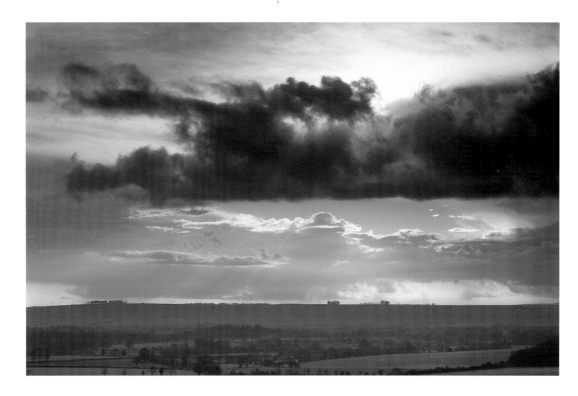

Above
Cloudscape over Pewsey Vale
The broad sweep of the Vale lies in shadow against the distant
ridge of Salisbury Plain with its distinctive tree clumps.

Left
Rainstorm approaches Ramsbury
A group of mature trees on the skyline is dwarfed by huge, threatening thunder clouds.

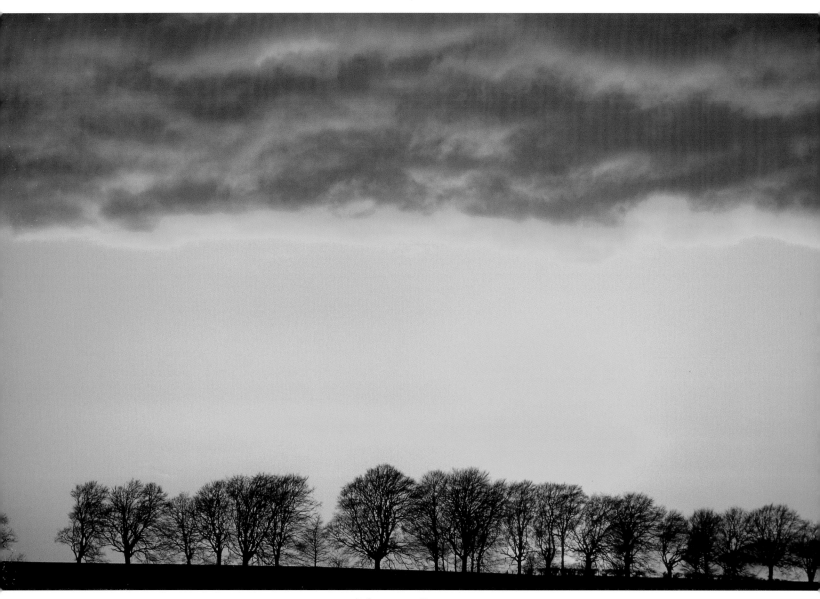

A bare treeline
A simple line of trees on Corton Hill stands under a simple line of clouds, colour-washed at sunset.

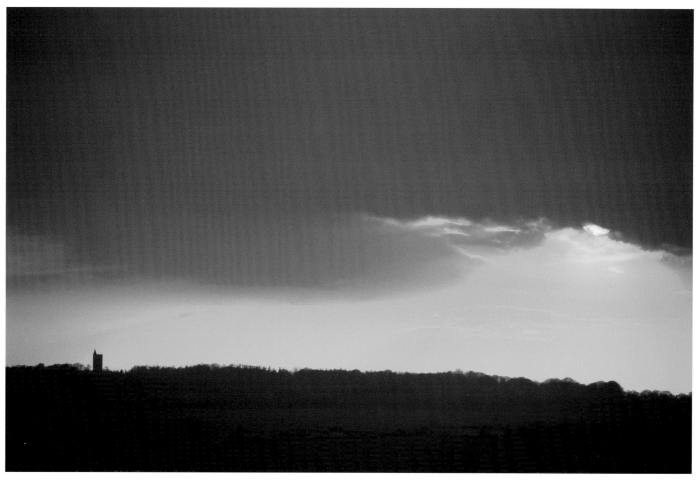

King Alfred's Tower
Standing on White Sheet Hill, you can see the tall, intriguing brick folly way off on Kingsettle Hill near Stourhead.

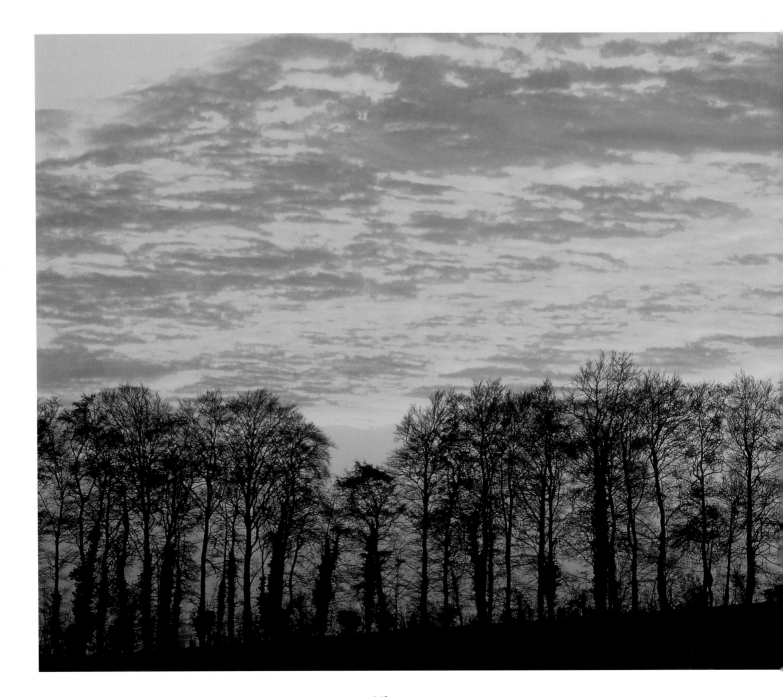

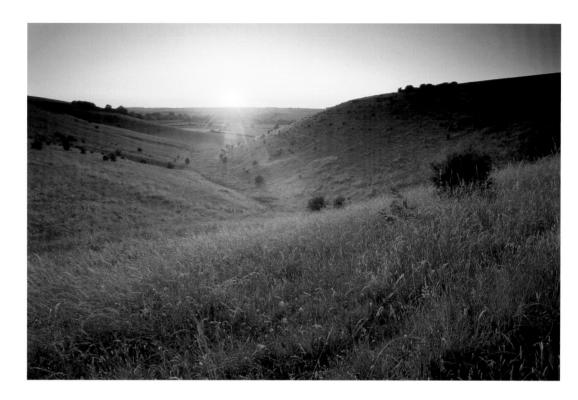

Above
Sunset at Knowle Down
Evening light strikes the steep sides of the coombe and suffuses the scene with orange.

Left
Beech trees in winter
Many trees cannot grow on thin, dry, alkaline chalk soils but the beech positively thrives.

143

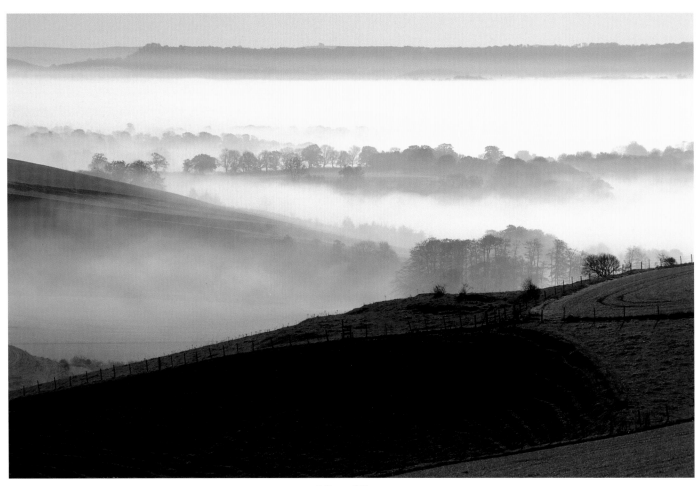

Misty Mere
A silver mist fills the sleepy valley below Mere Down, giving tantalising
glimpses of what will soon be revealed by the warmth of the sun.